SMITTEN

a kitten's guide to happiness

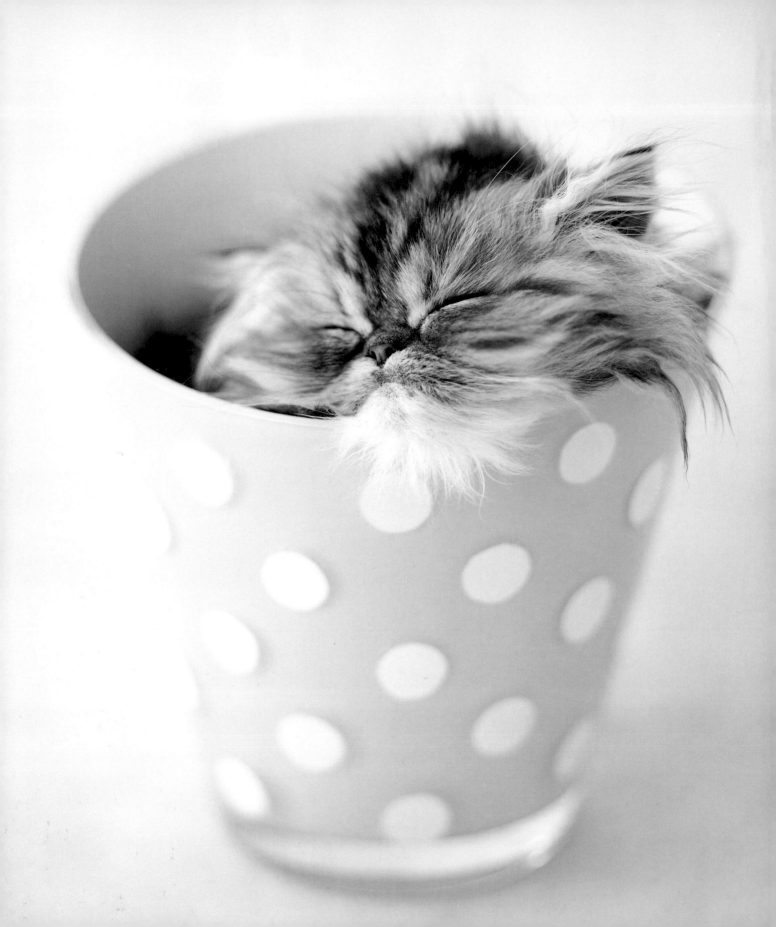

SMITTEN

a kitten's guide to happiness

RACHAEL HALE

Bulfinch Press
New York • Boston

HAPPINESS IS THE MEANING AND THE PURPOSE OF LIFE,
THE WHOLE AIM AND END OF ~~HUMAN~~ EXISTENCE.

ARISTOTLE FELINE
 ^

To me, kittens epitomize a life lived for sheer pleasure.

When my cat Edmund was a kitten, his sole purpose in life, when not fast asleep, was to pack each day with adventure. His favorite adventure was to tease my Newfoundland Henry, something he was exquisitely adept at. Edmund would leap on the unsuspecting Henry's tail then beat a hasty retreat to a spot just out of his reach so that the large dog could do nothing to stop his minute and cheeky tormentor.

Edmund's tiny body and large, uncoordinated feet meant his escapades were usually accompanied by unglamorous splatters on the floor as his ill-timed leaps through the indoor jungle went awry. Awake, Edmund seemed filled with a sense of wonder as every object in his path – chair, person, animal or shadow – promised new discoveries. Asleep, he was angelic. Lying on his back or curled into one of those unbelievable kitten contortions, he always had a smile on his face, not a worry in the world. I spent hours just kitten watching.

The *joie de vivre* exuded by Edmund and the pleasure kittens bring into all our lives with their endearing antics and their sense of fun convinced me that a kitten is the perfect illustration for a guide to happiness.

RACHAEL HALE

Too much of a good thing can be wonderful.

MAE WEST

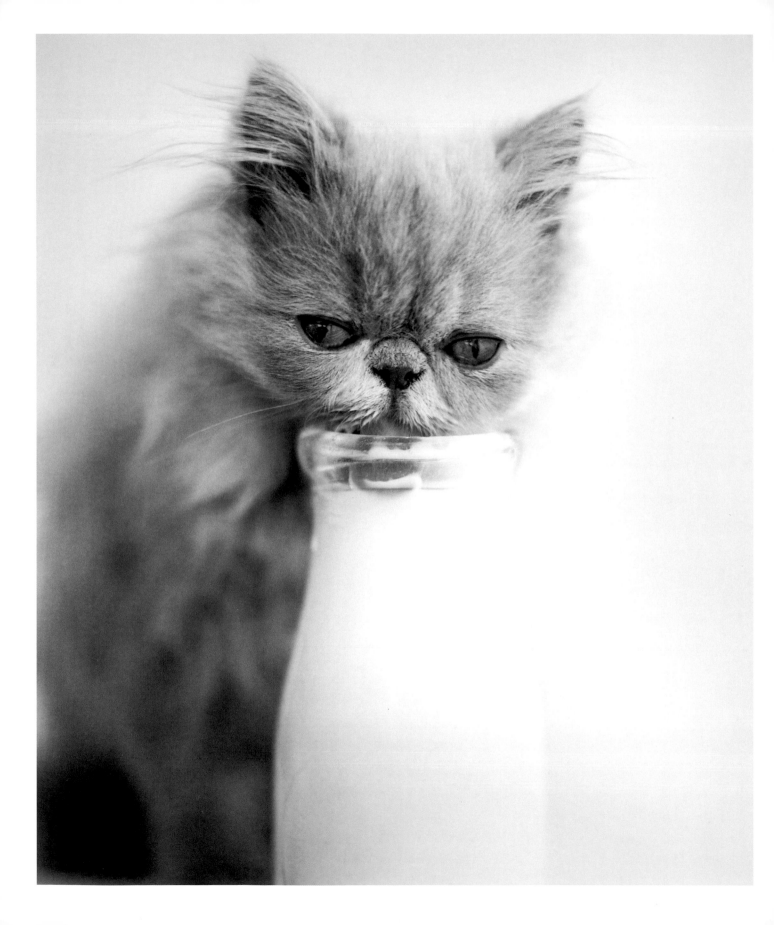

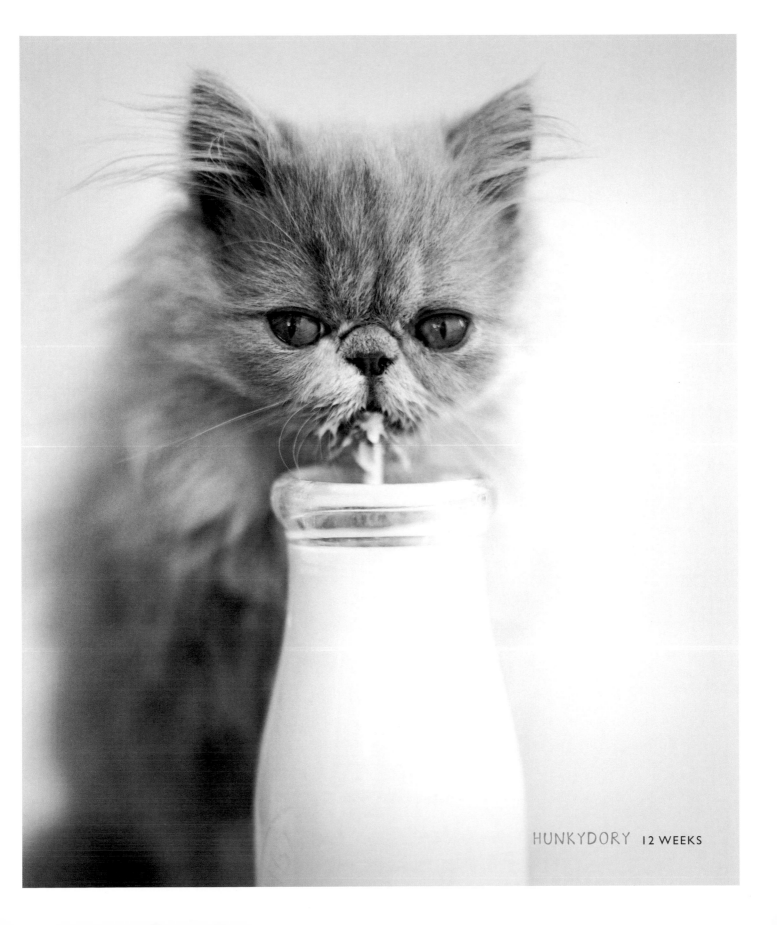

HUNKYDORY 12 WEEKS

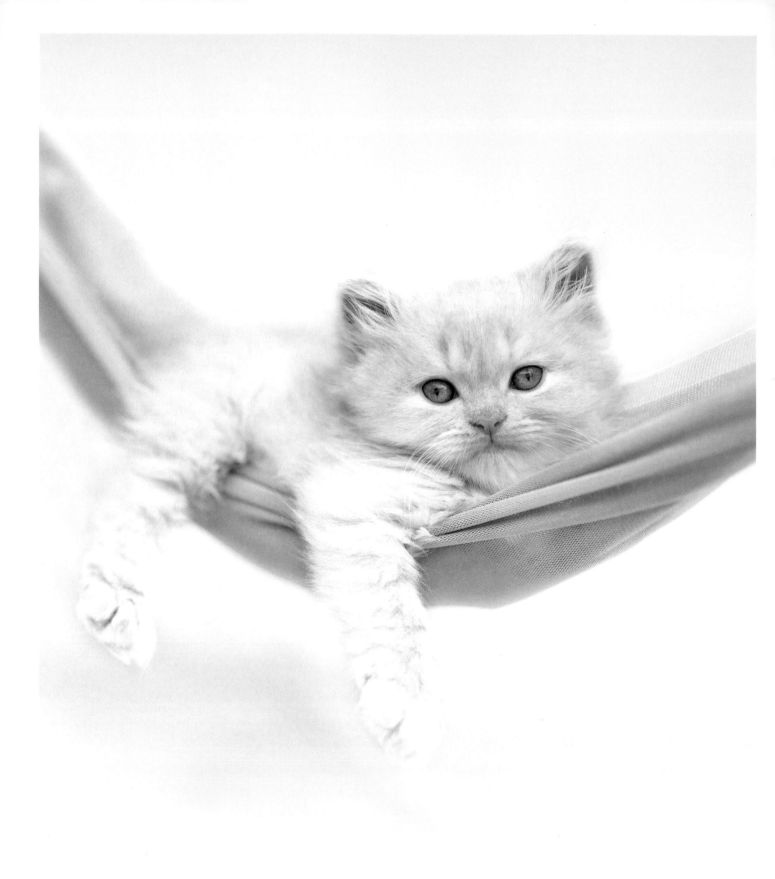

Consciousness:

that annoying time between naps.

ANONYMOUS

DAISY **7 WEEKS** ▶

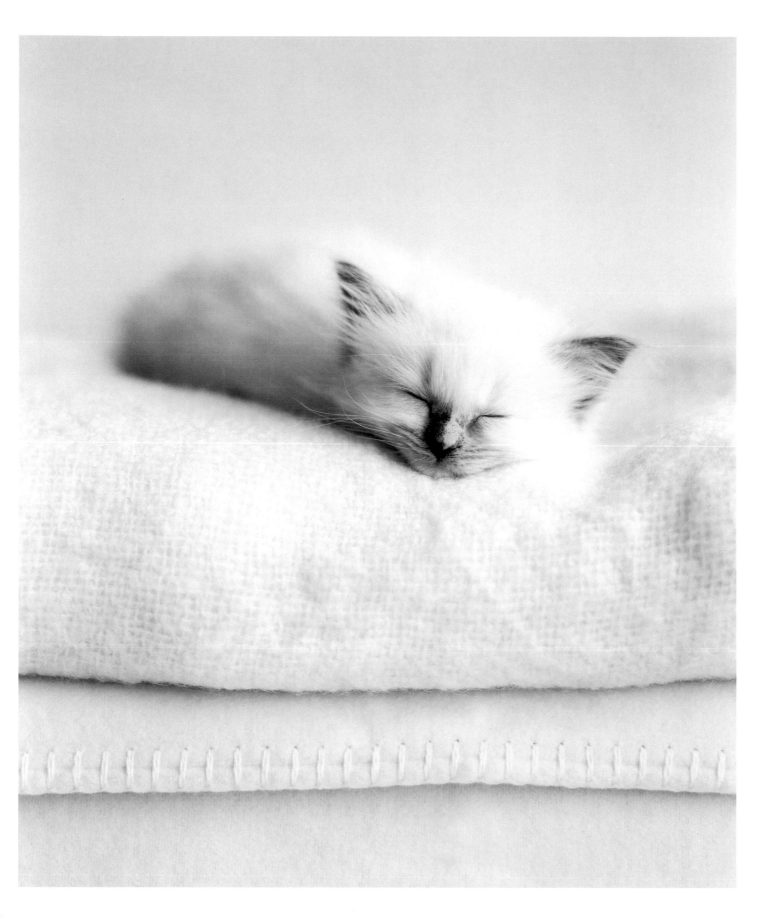

Looking good and dressing well is a necessity.

Having a purpose in life is not.

OSCAR WILDE

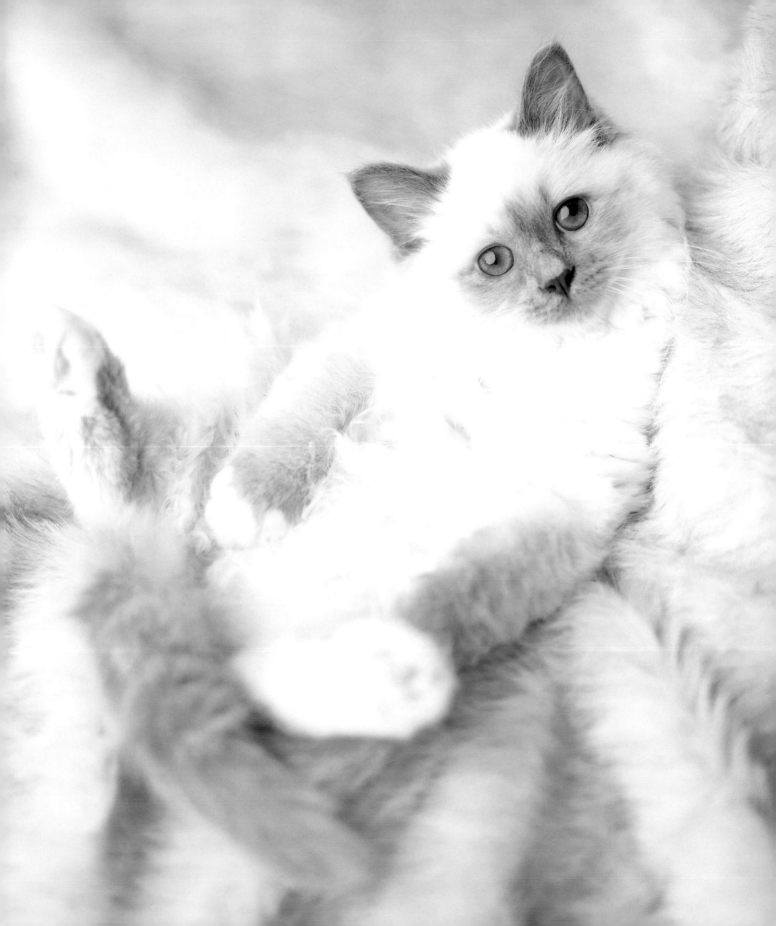

MINNIE 3 MONTHS ▶

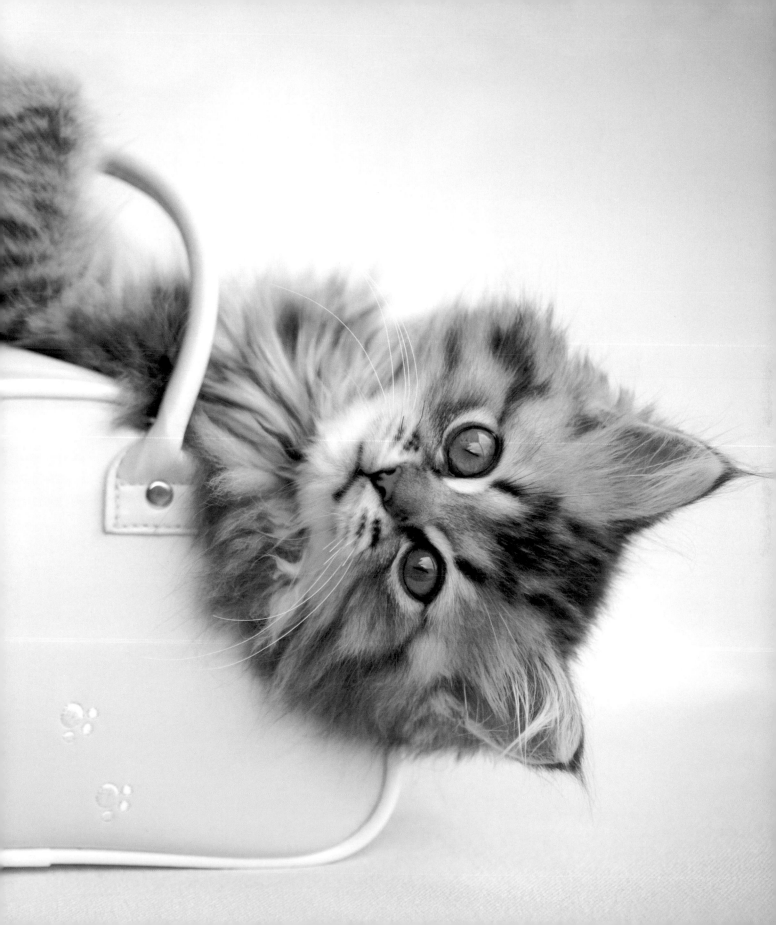

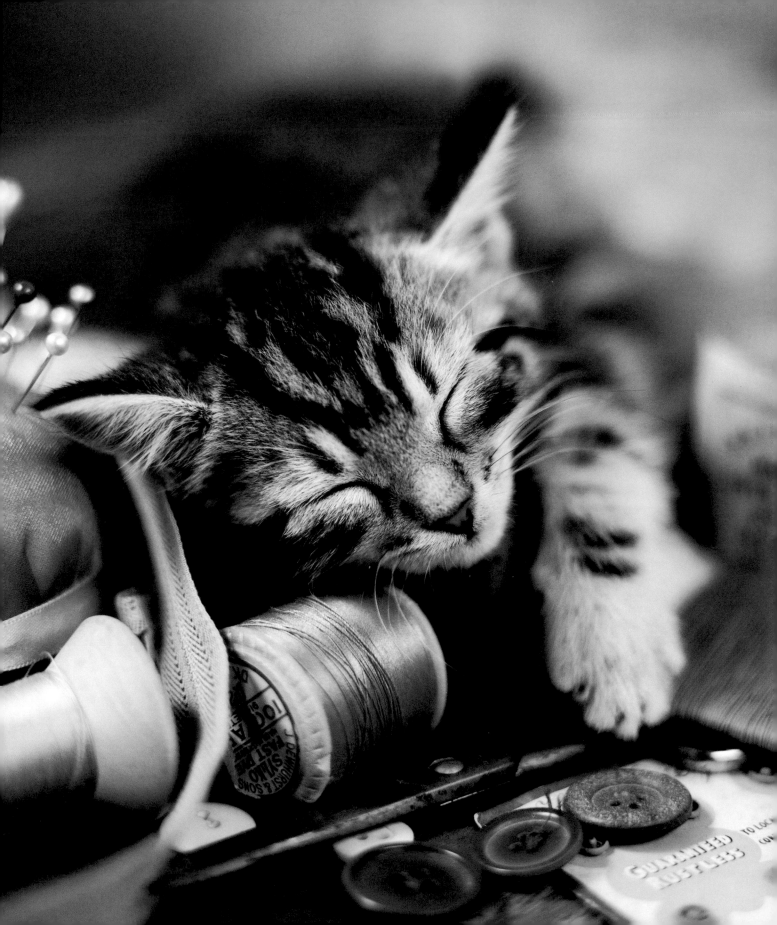

Now and then it's good to pause

in our pursuit of happiness

and just be happy.

GUILLAUME APOLLINAIRE

It's never too late to have a happy childhood.

TOM ROBBINS

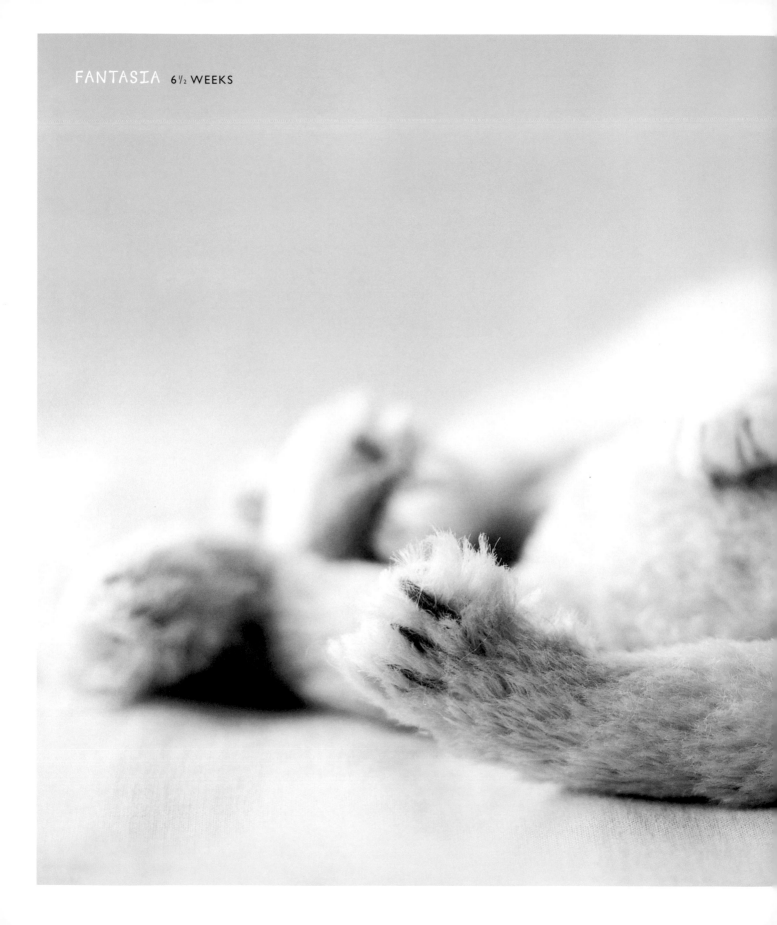

FANTASIA 6 ½ WEEKS

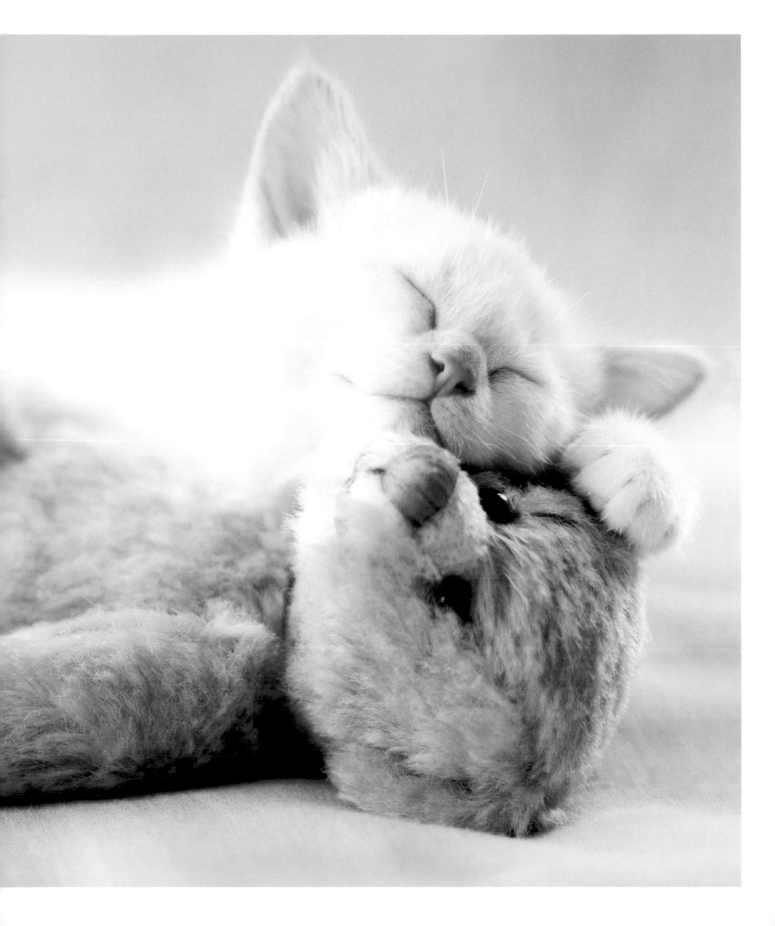

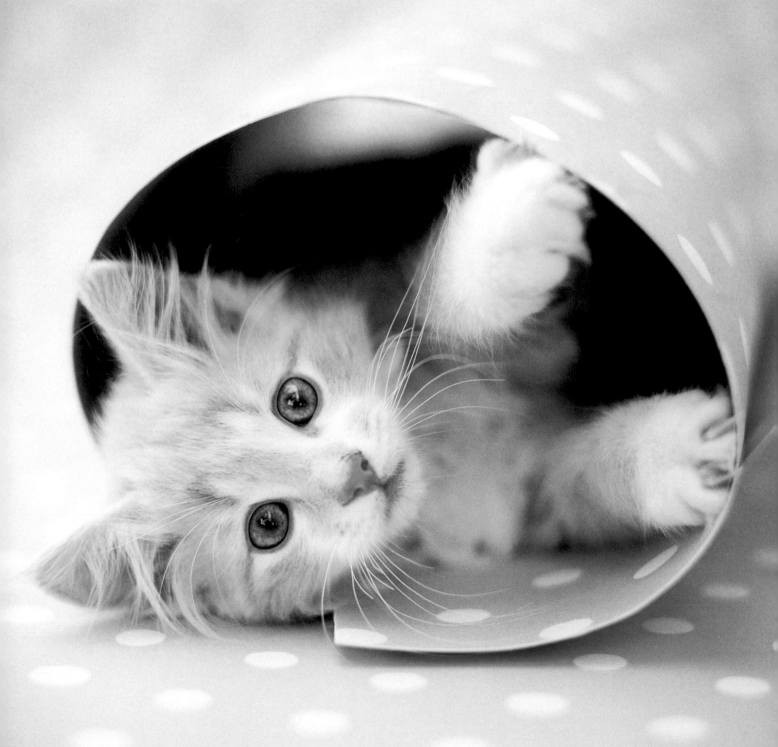

It is better to waste one's youth than

do nothing with it at all.

GEORGE COURTELINE

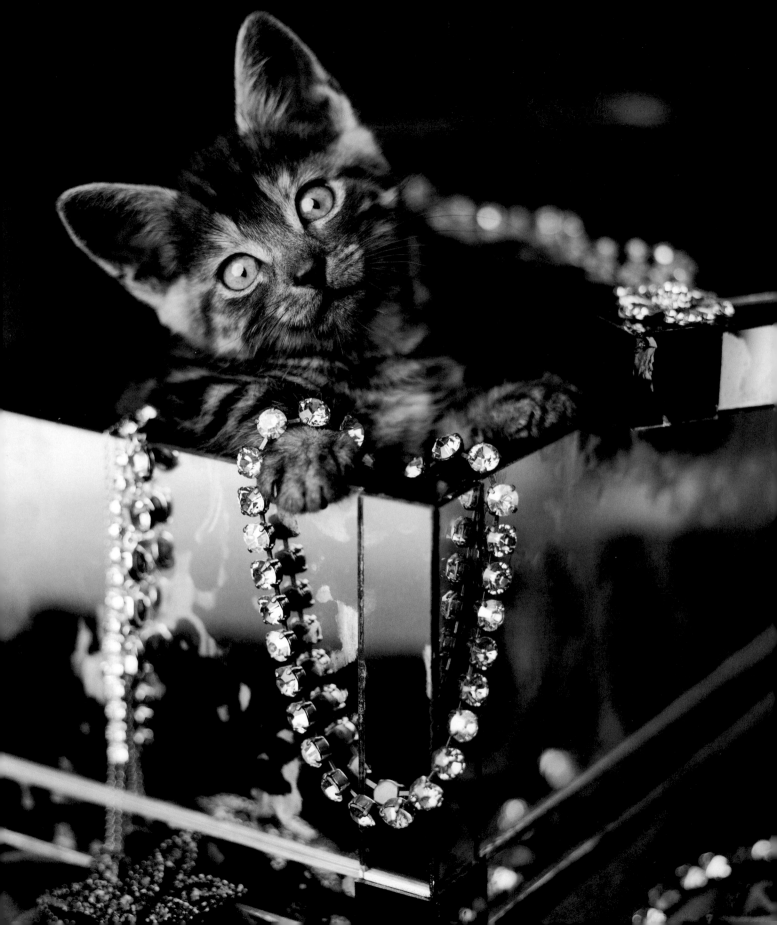

◄ LILA 5½ WEEKS

Don't mistake motion for action.

RACHAEL HALE

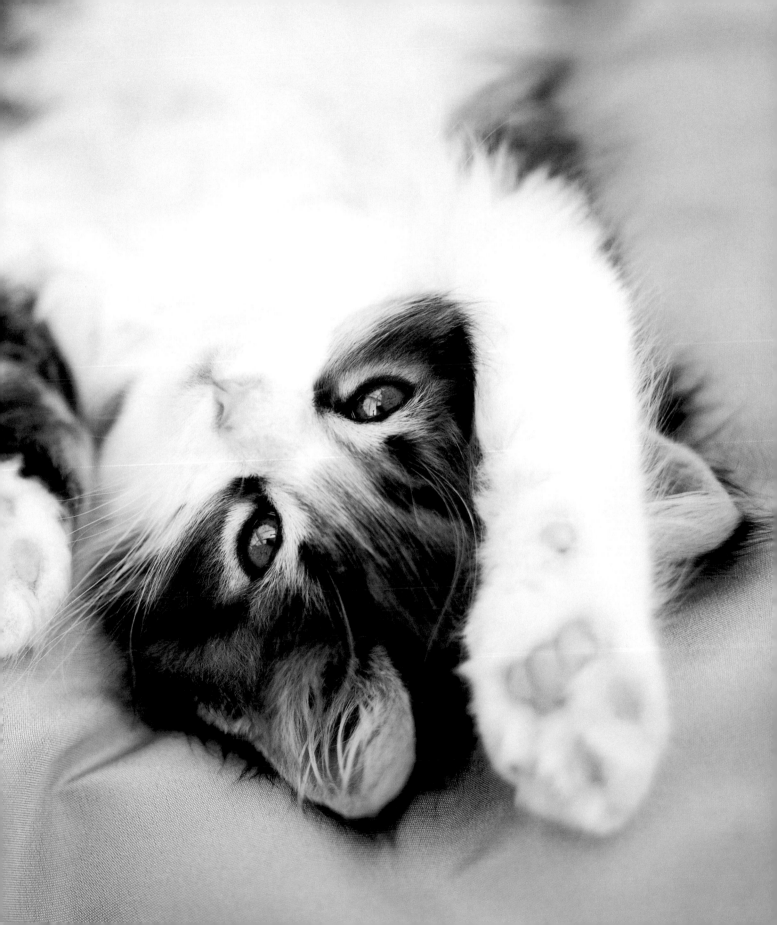

No day is so bad it can't be fixed with a nap.

CARRIE P. SNOW

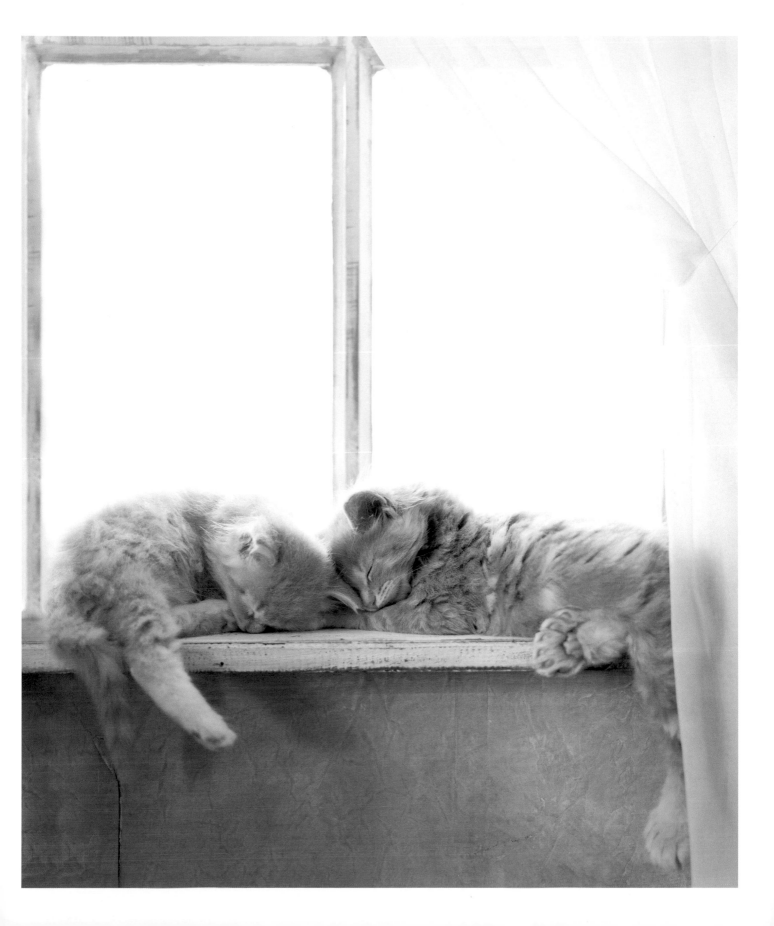

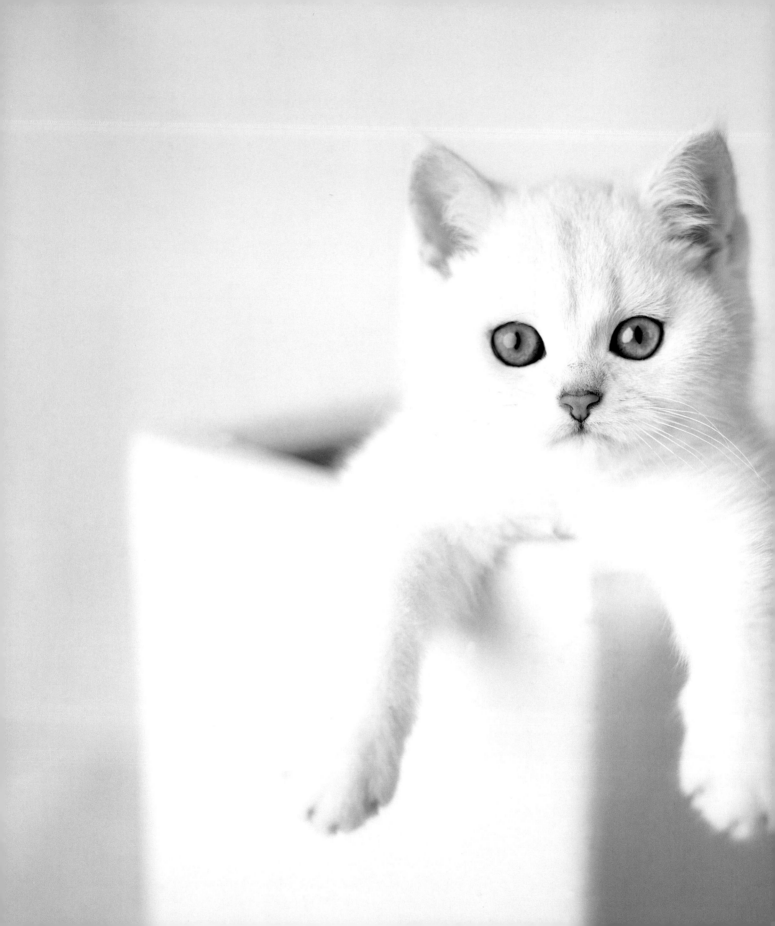

Always strive to excel,

but only on weekends.

ANONYMOUS

Nothing's impossible for those who don't have to do it.

PROVERB

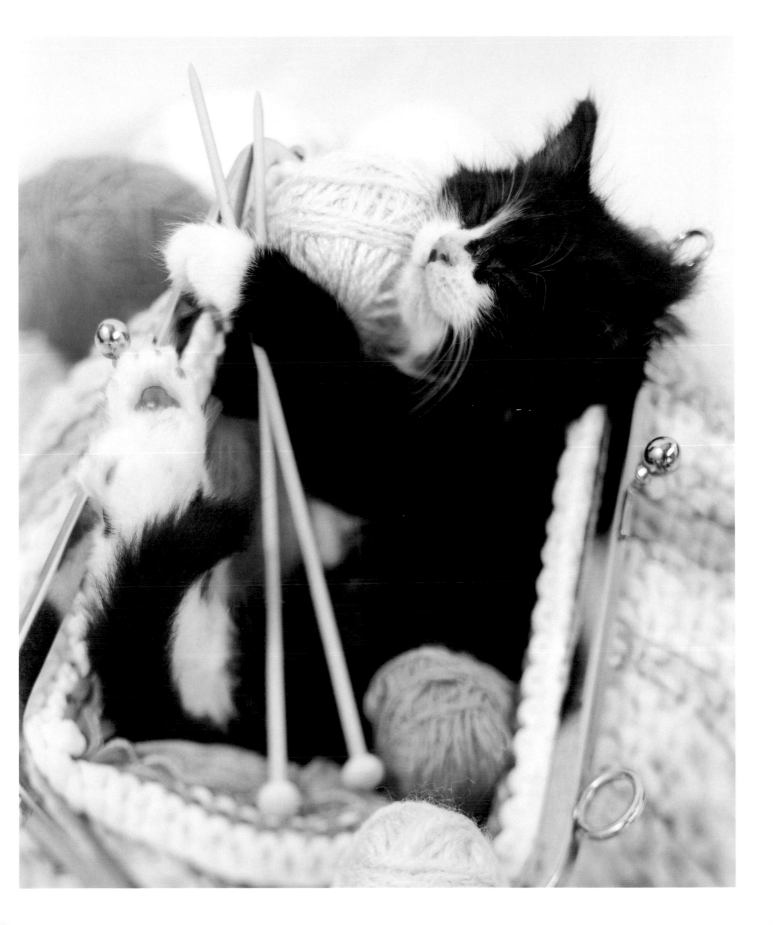

It's important to have friends in high places...

ACHILLES & APOLLO **6 WEEKS** ▶

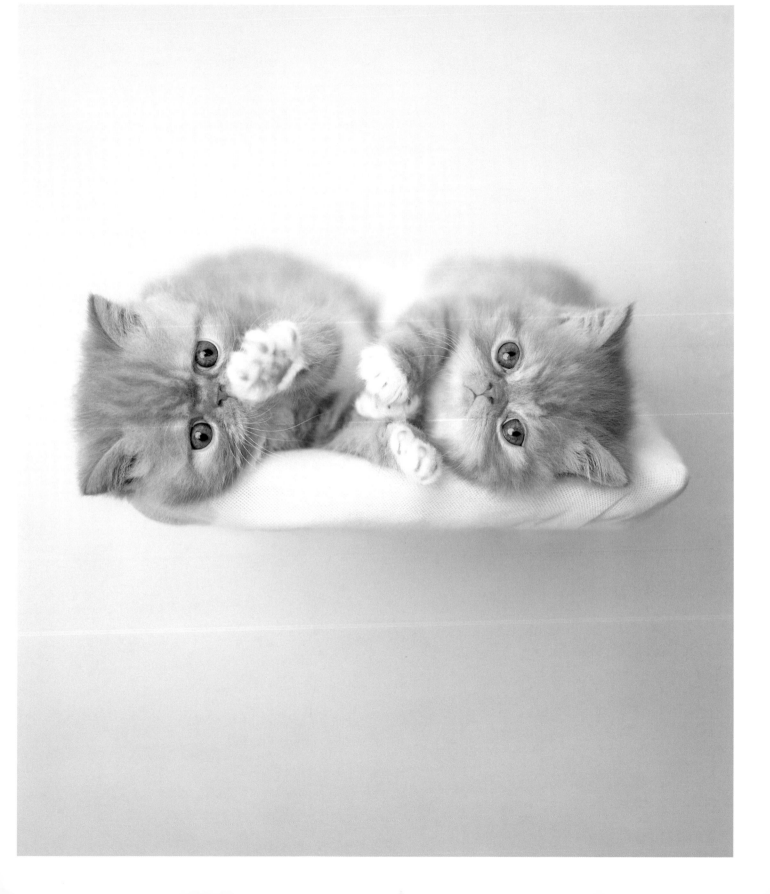

especially when in a tight spot.

RACHAEL HALE

BUBBLES & SQUEAK 4 WEEKS ▶

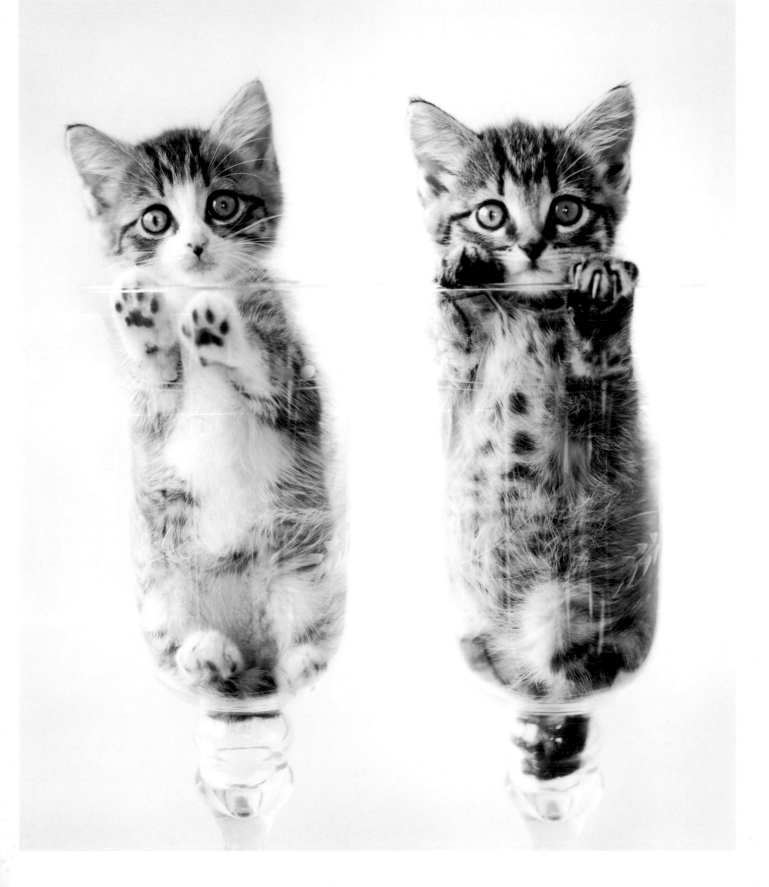

No problem is ever so big it can't be run away from.

ANONYMOUS

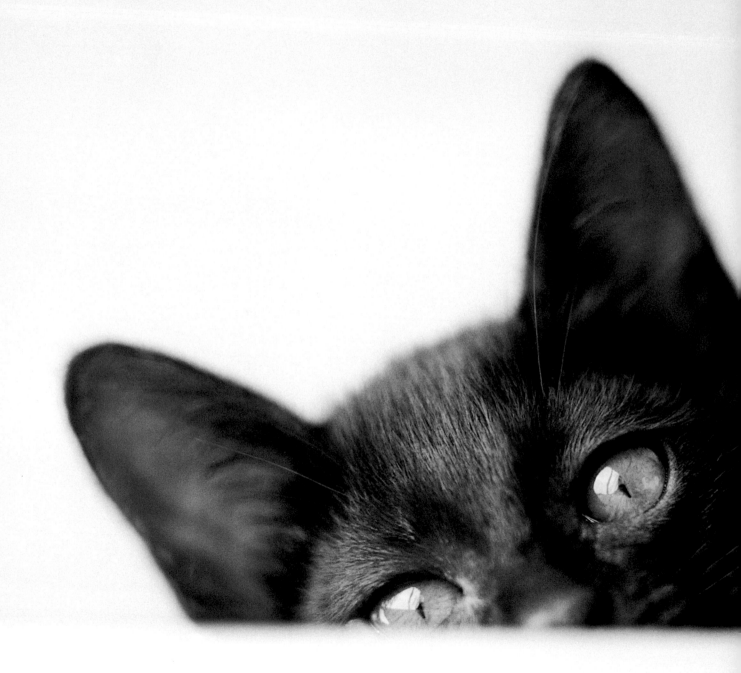

The best way out is always through.

ROBERT FROST

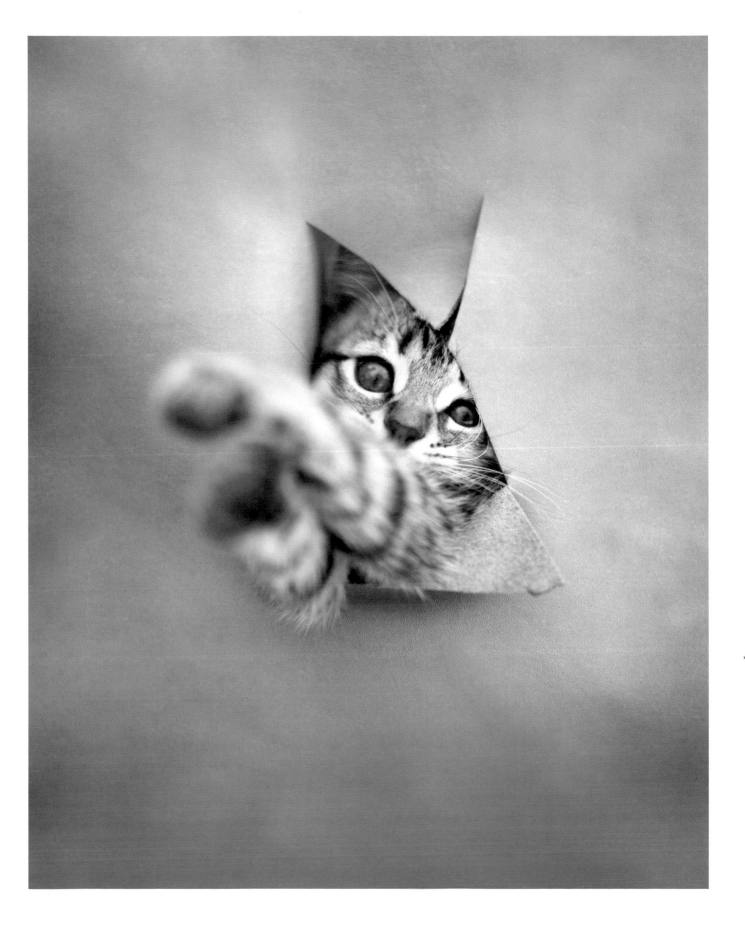

Difficulties…

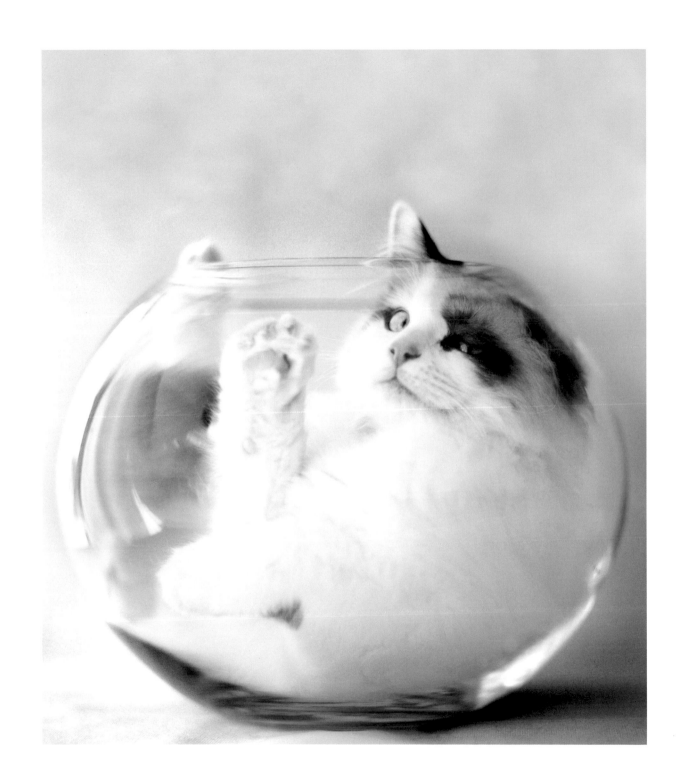

▲ ALFIE 4 MONTHS

are stepping stones to success.

PROVERB

EDDIE 10 WEEKS ▶

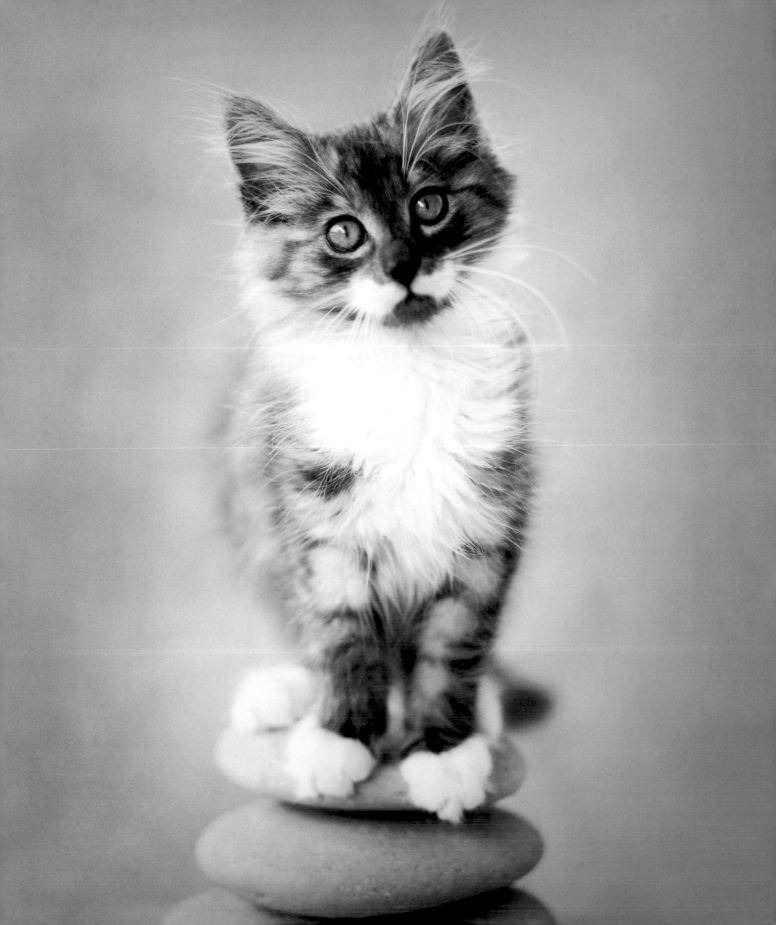

Things are never quite as scary

when you've got a best friend.

BILL WATTERSON

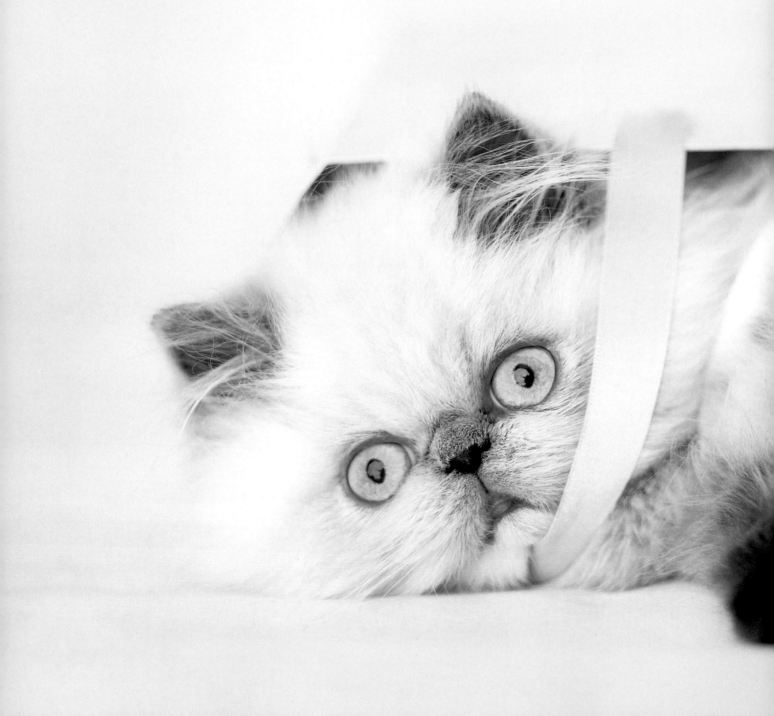

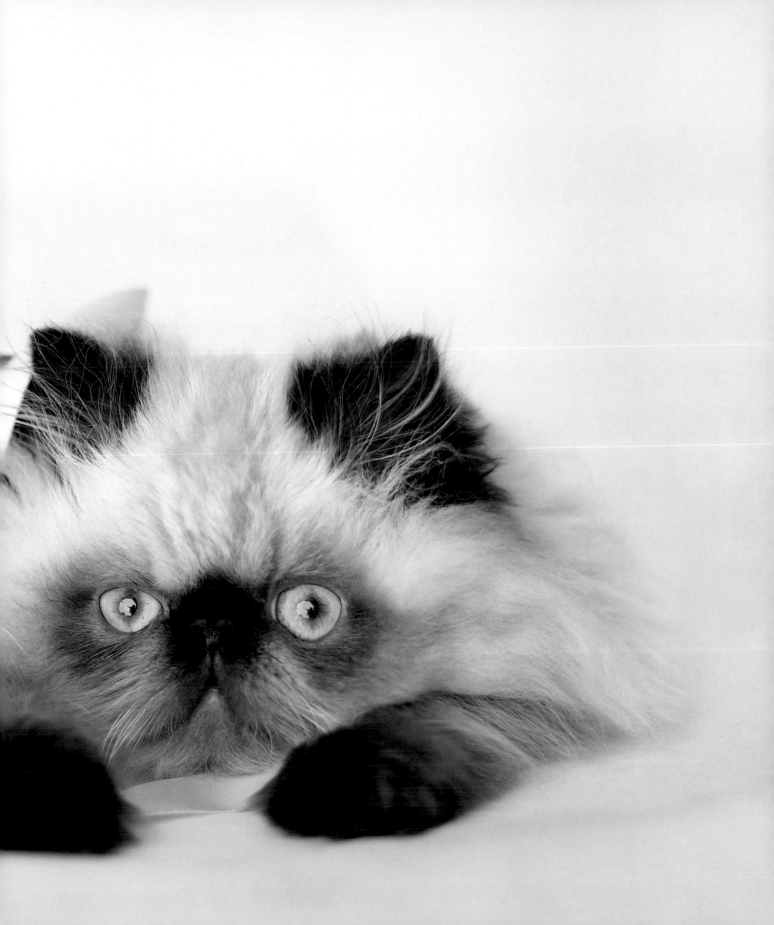

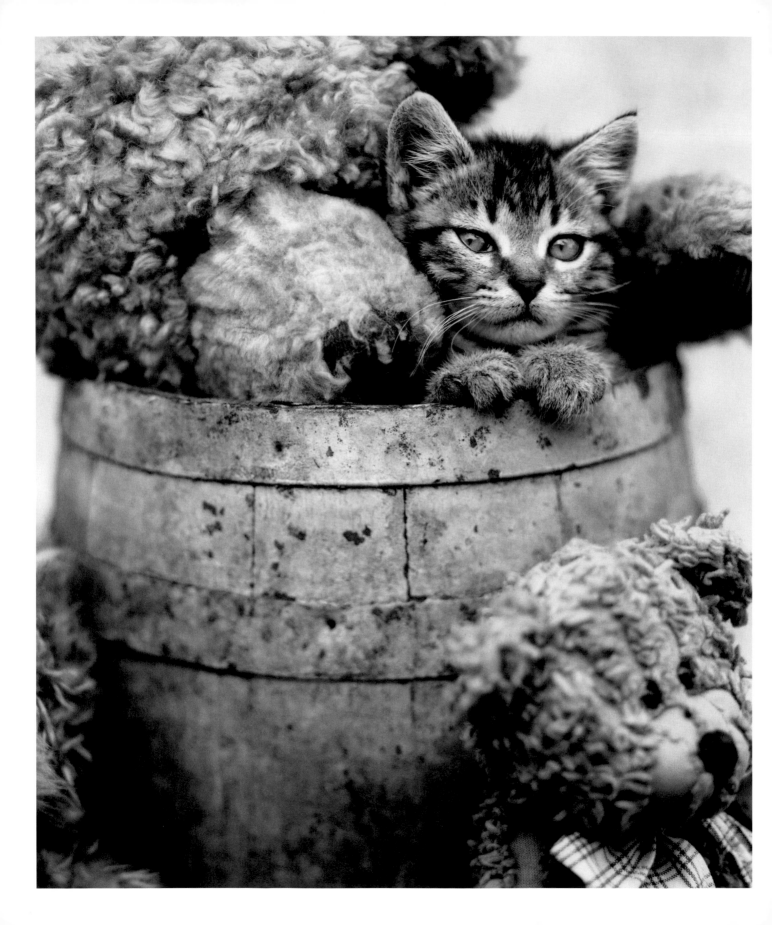

Keep your friends close…

and your enemies closer.

PROVERB

MUGGLE, NIGEL & DEREK **7 WEEKS** ▶

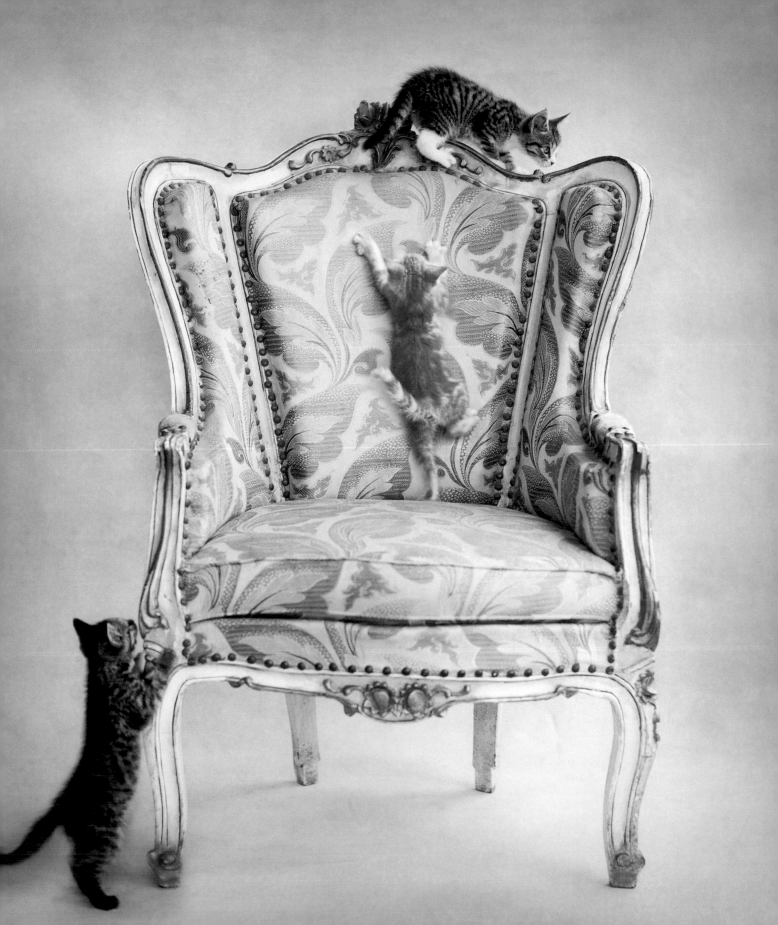

Friendship is like vitamins – you supplement

each other's minimum daily requirements.

ANONYMOUS

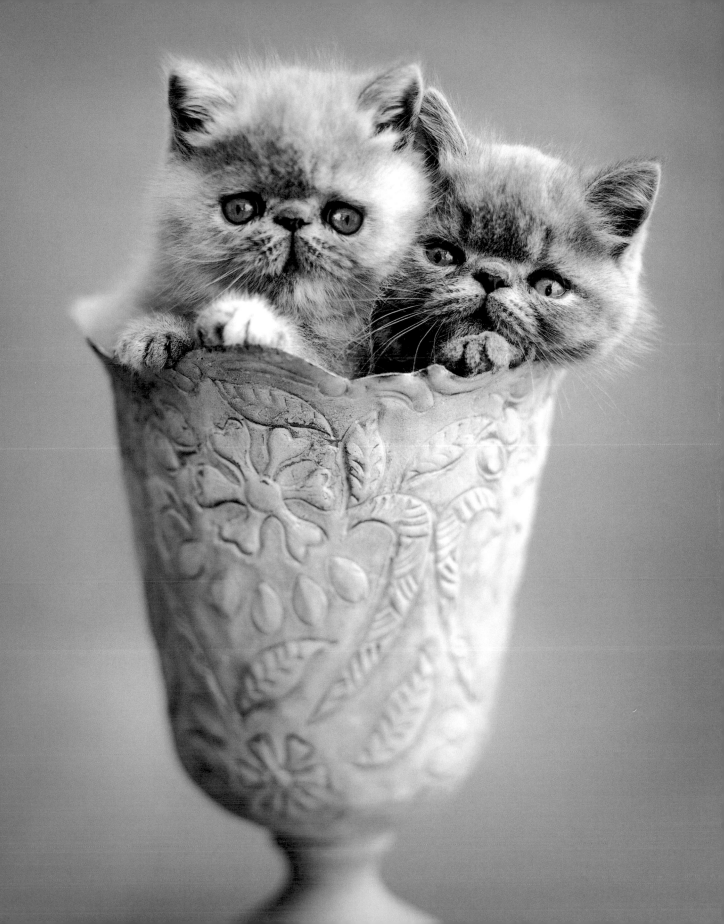

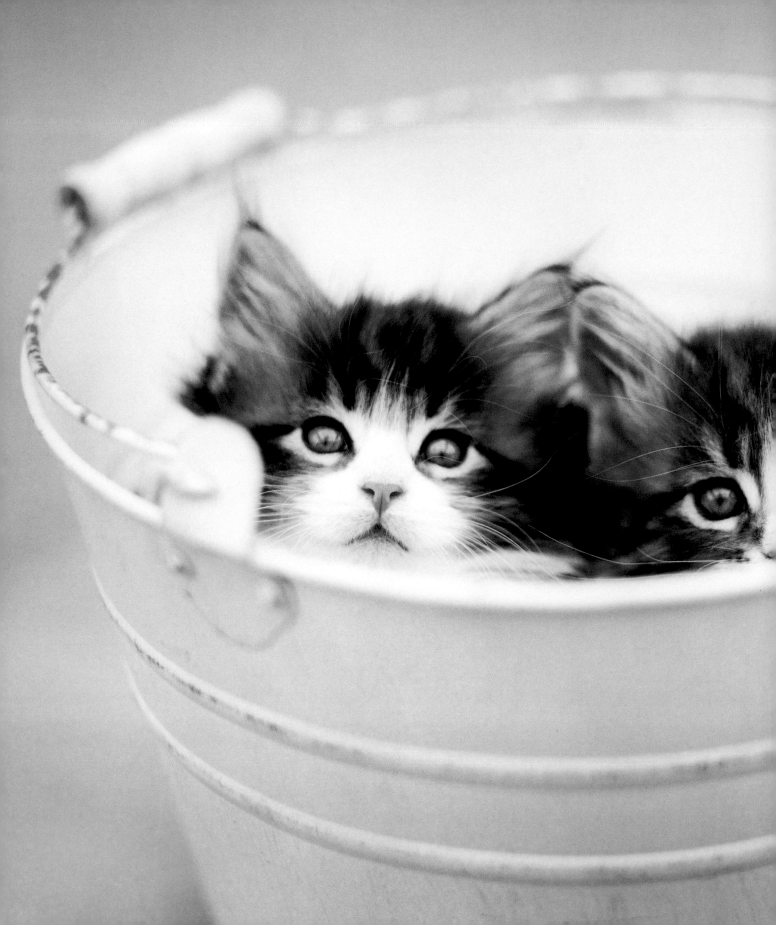

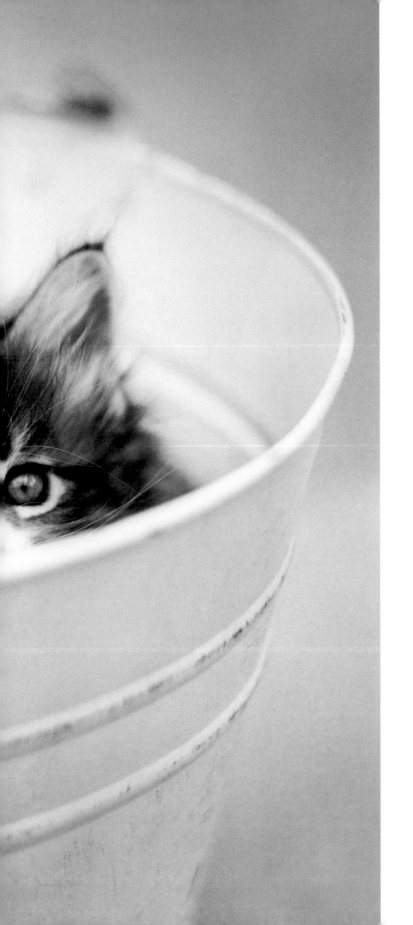

Two's company...

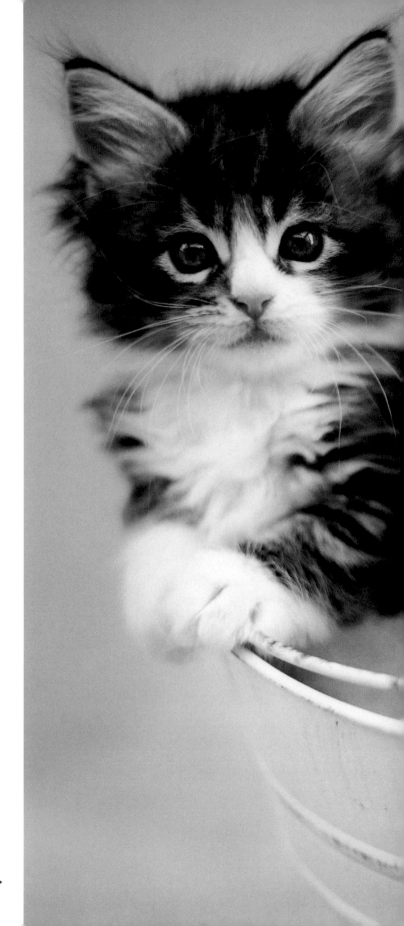

three's a crowd.

PROVERB

DOMINIC, SAM & JACKSON 6¹/₂ WEEKS ▶

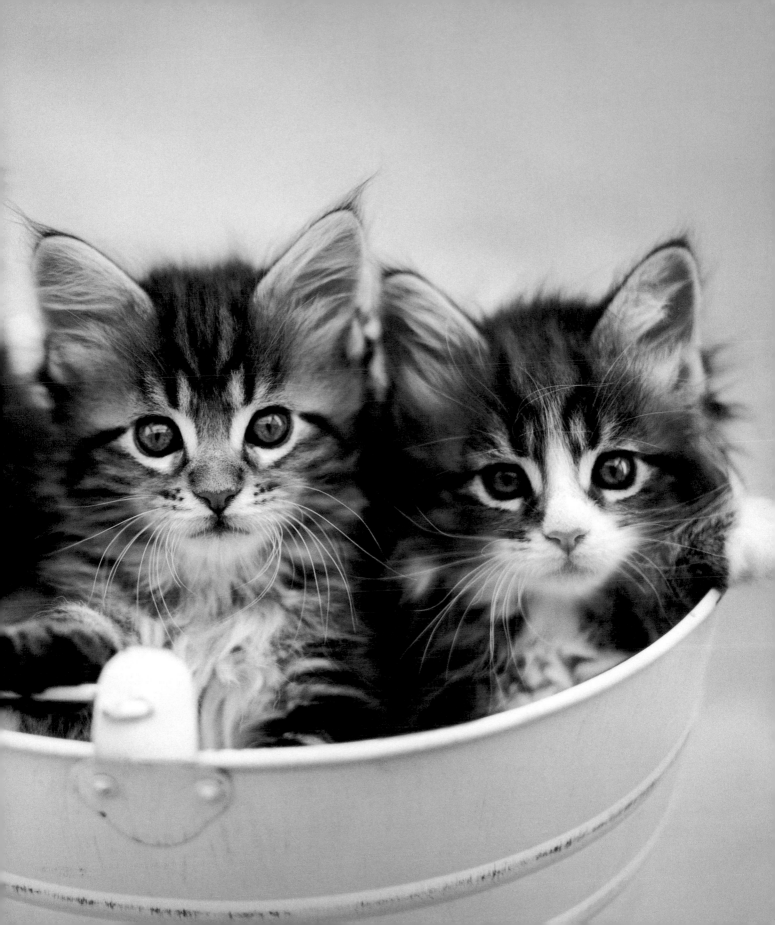

One good turn gets most of the blanket.

ANONYMOUS

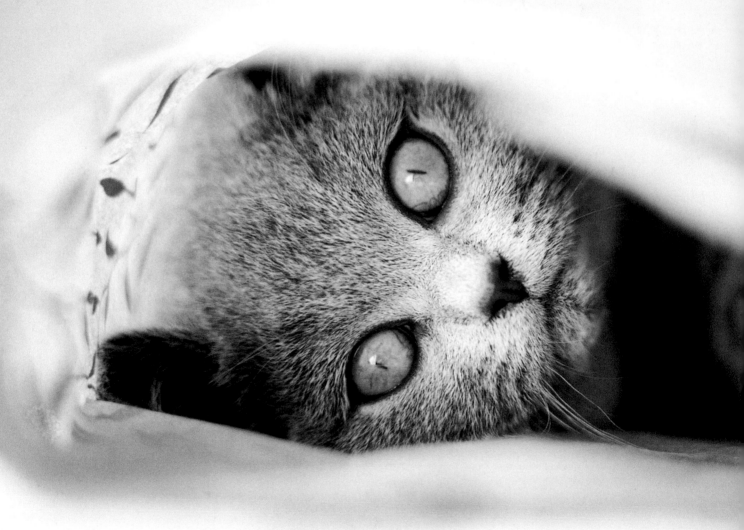

When you're looking for a friend, don't

look for perfection, just look for friendship.

PROVERB

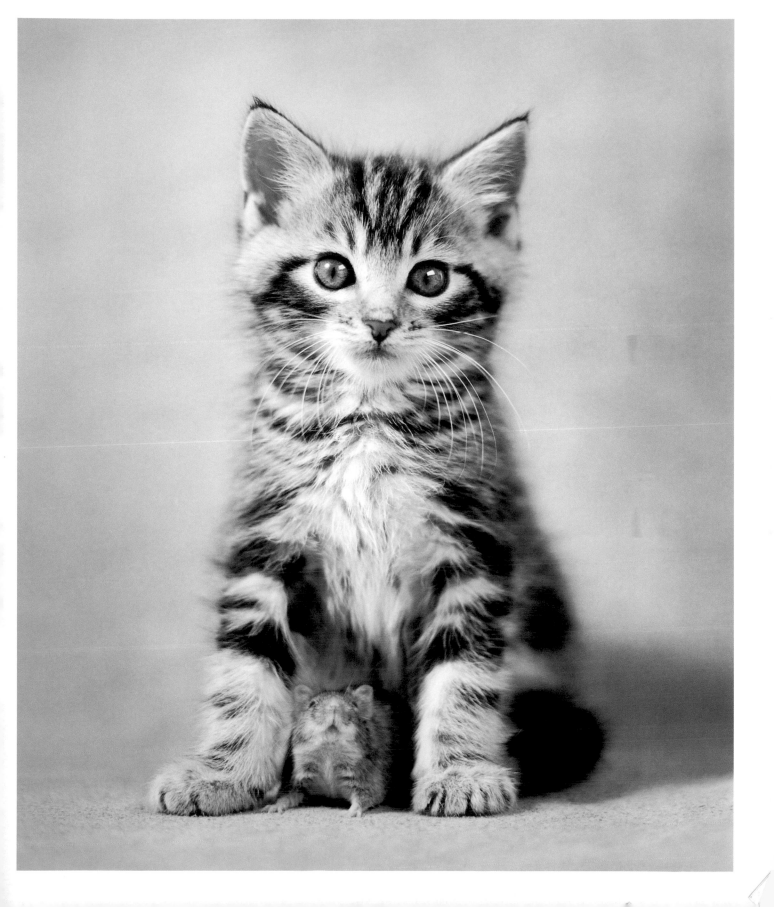

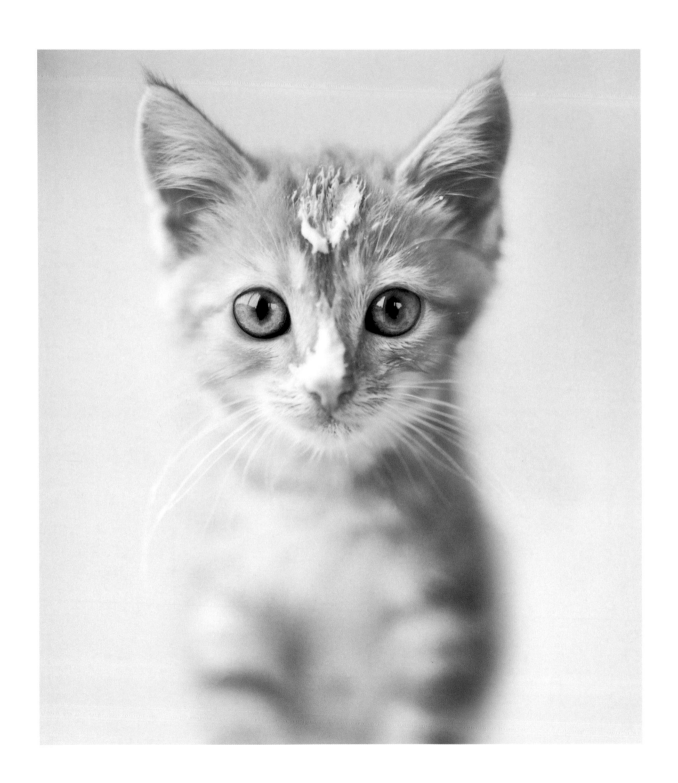

▲ NIGEL 7 WEEKS

After a good dinner one can forgive anybody.

OSCAR WILDE

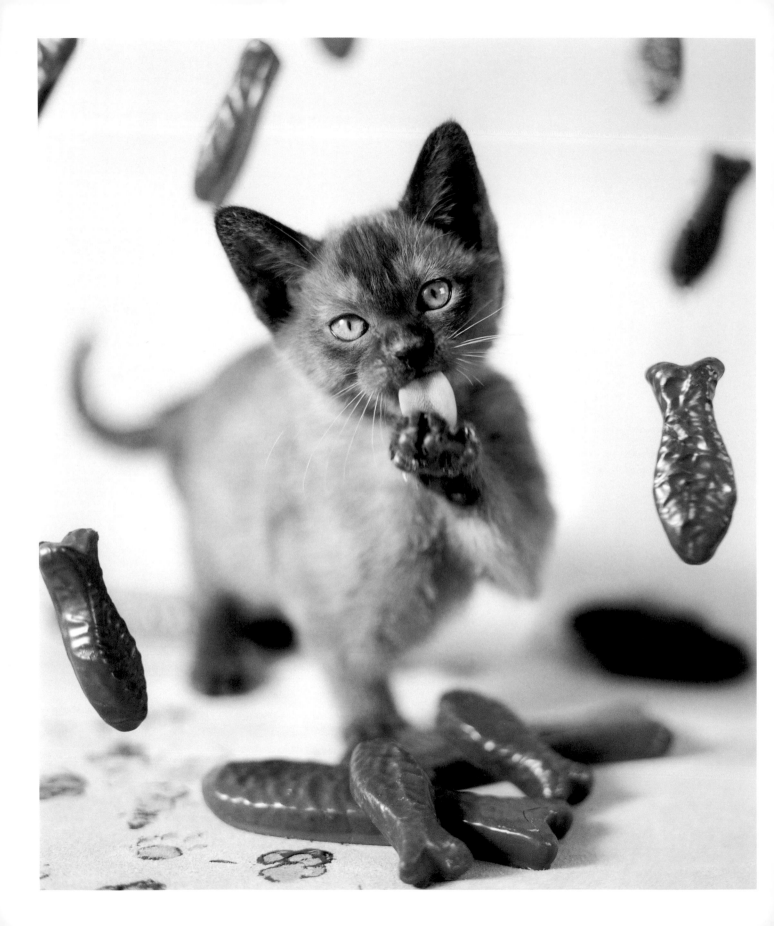

Avoid fruits and nuts...

you are what you eat.

JIM DAVIS

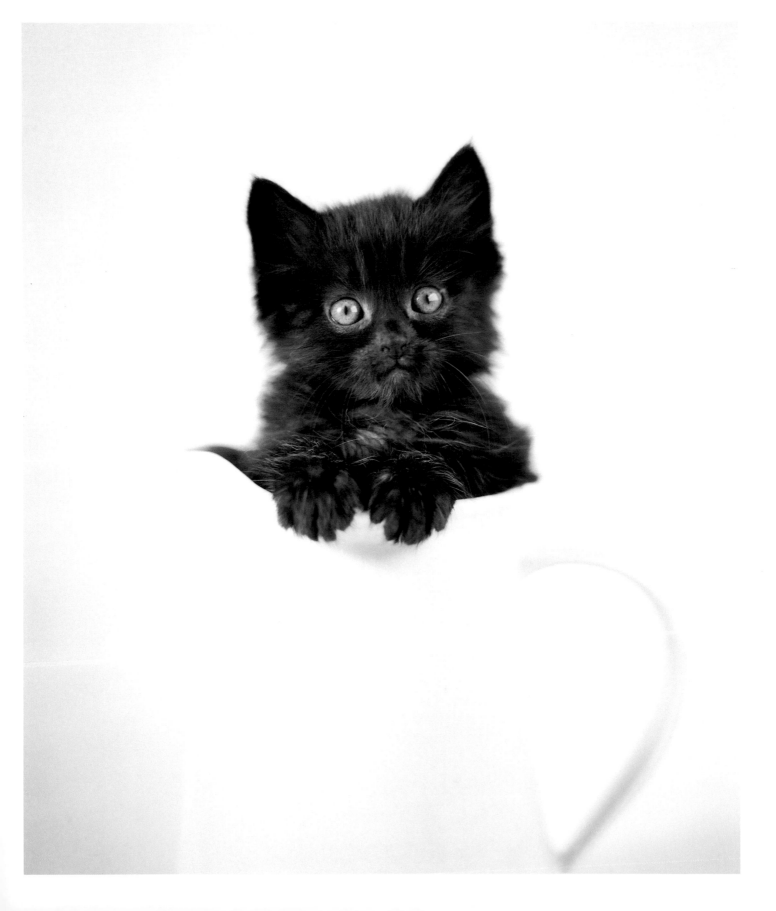

BONNIE & MILLIE 8 WEEKS ▶

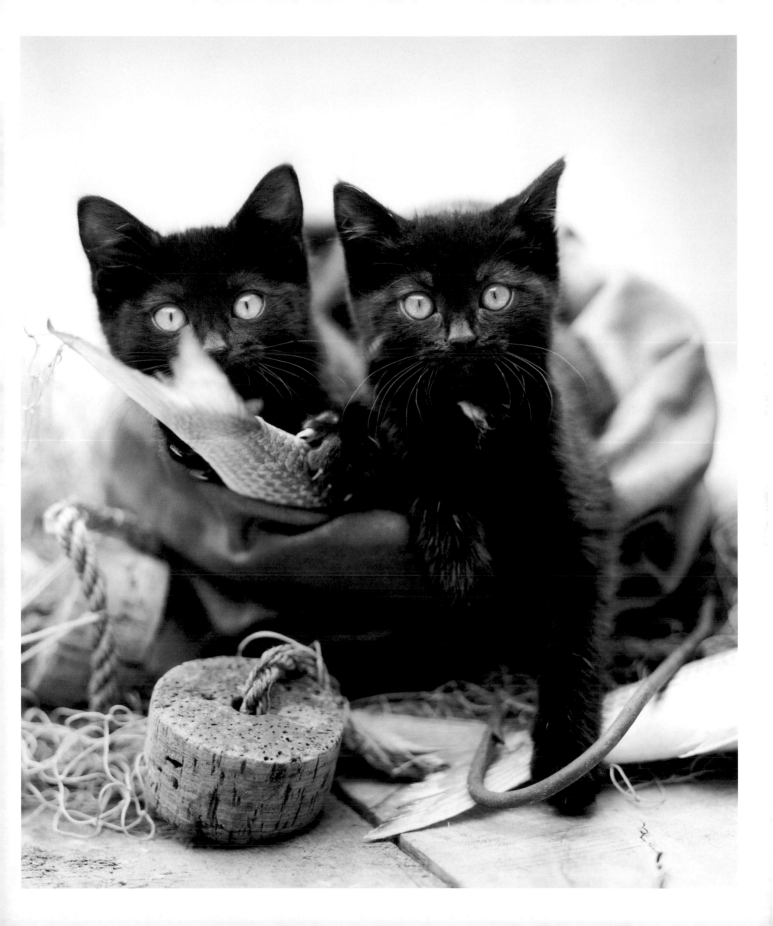

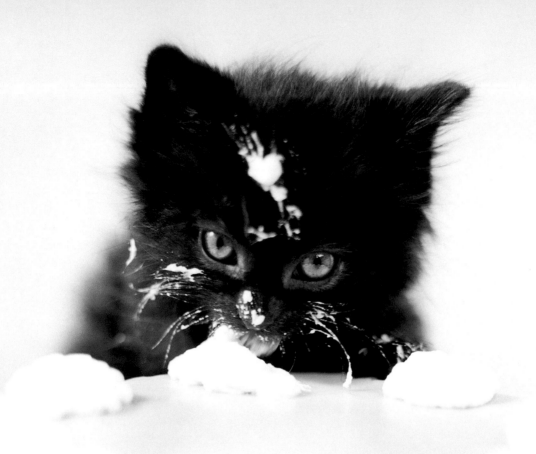

Stressed is desserts spelt backwards.

TRUISM

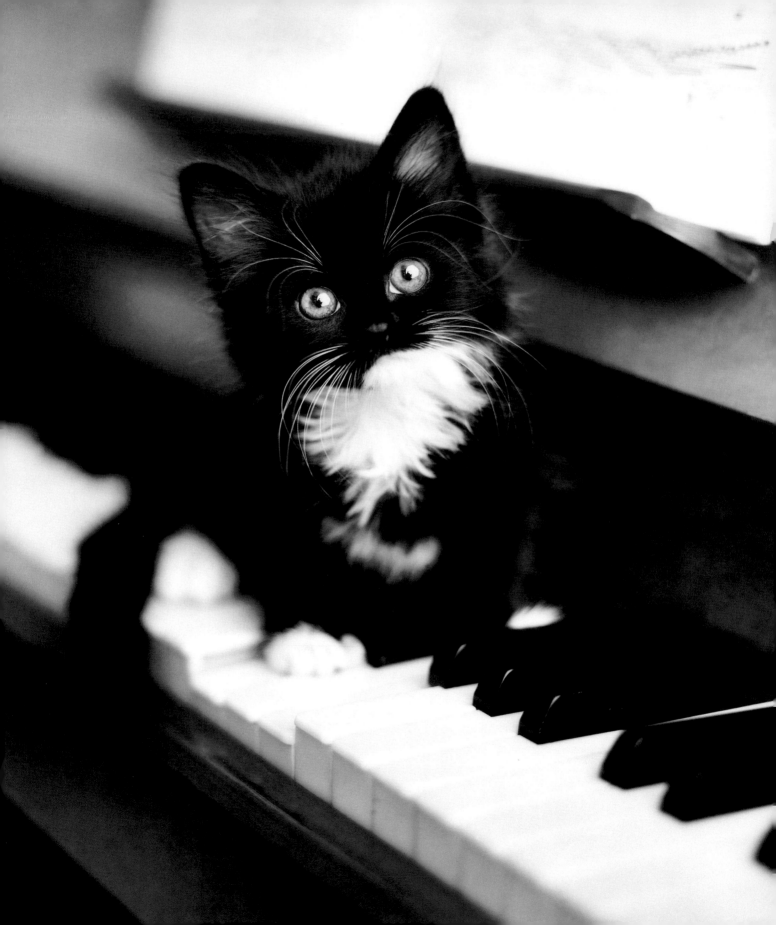

If music be the food of love, play on.

WILLIAM SHAKESPEARE

The cure for boredom is curiosity...

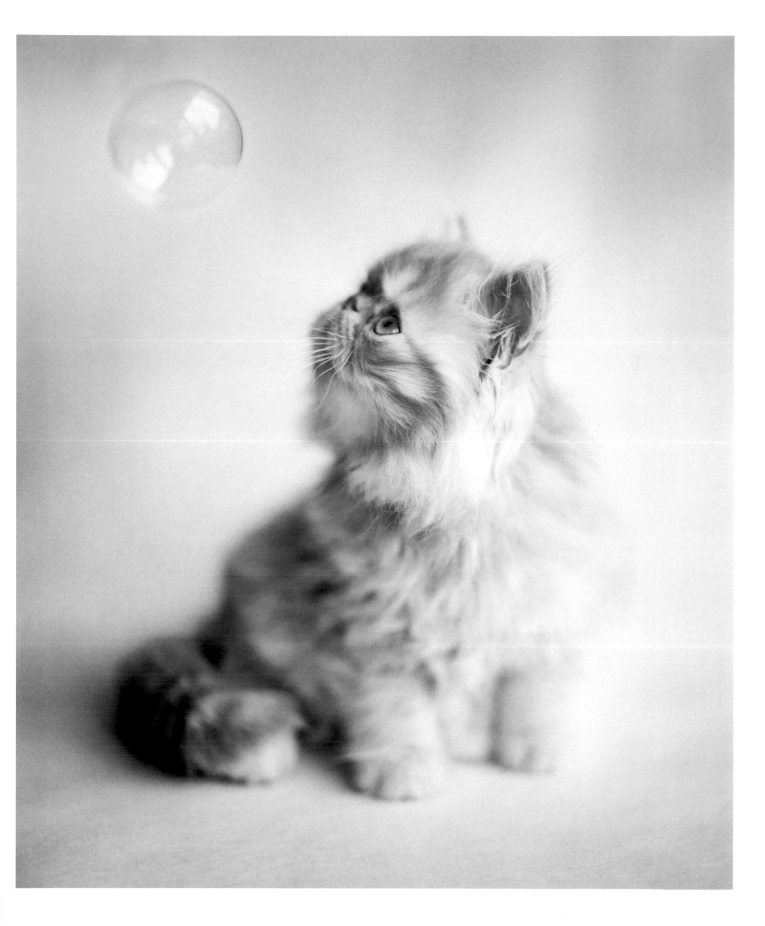

there is no cure for curiosity.

ELLEN PARR

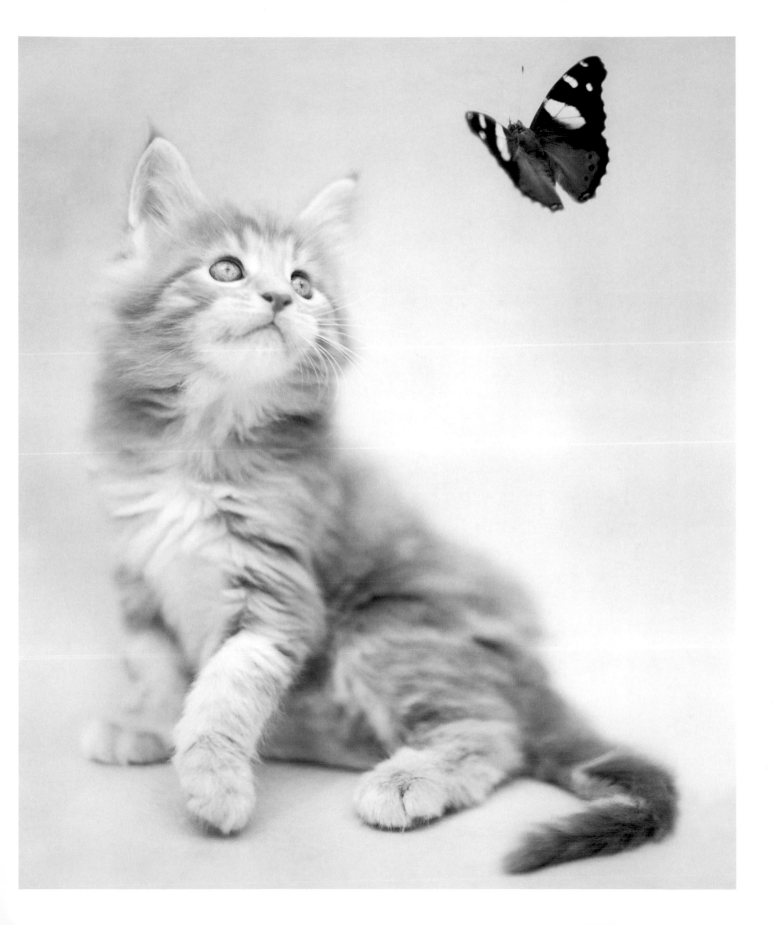

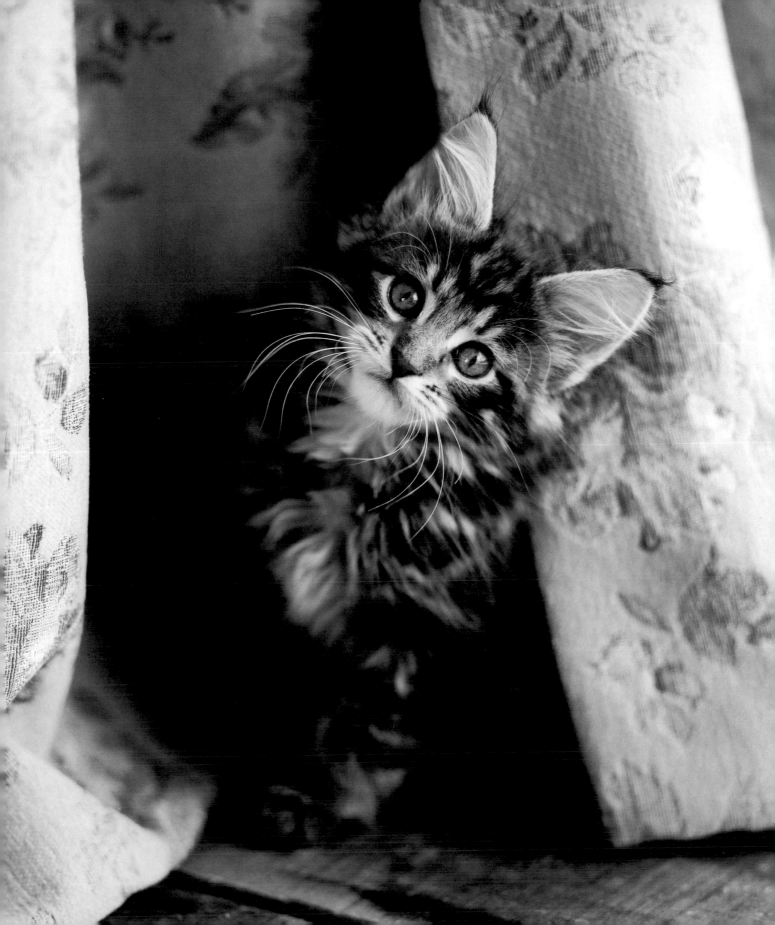

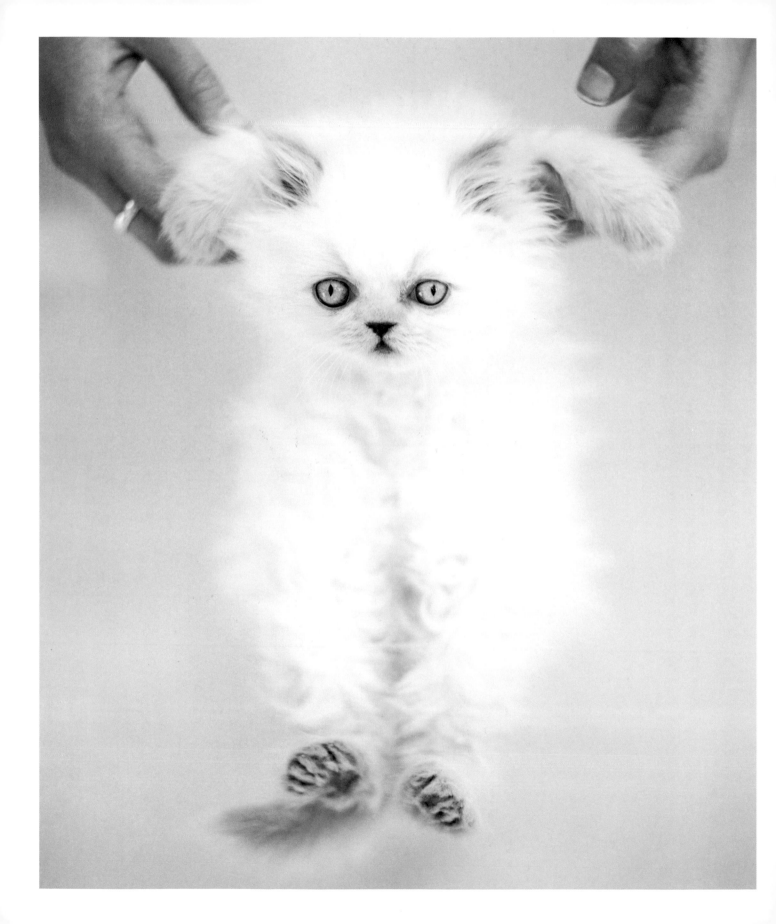

It is better to be looked over than overlooked.

MAE WEST

Egotism is not without its attractions.

OSCAR WILDE

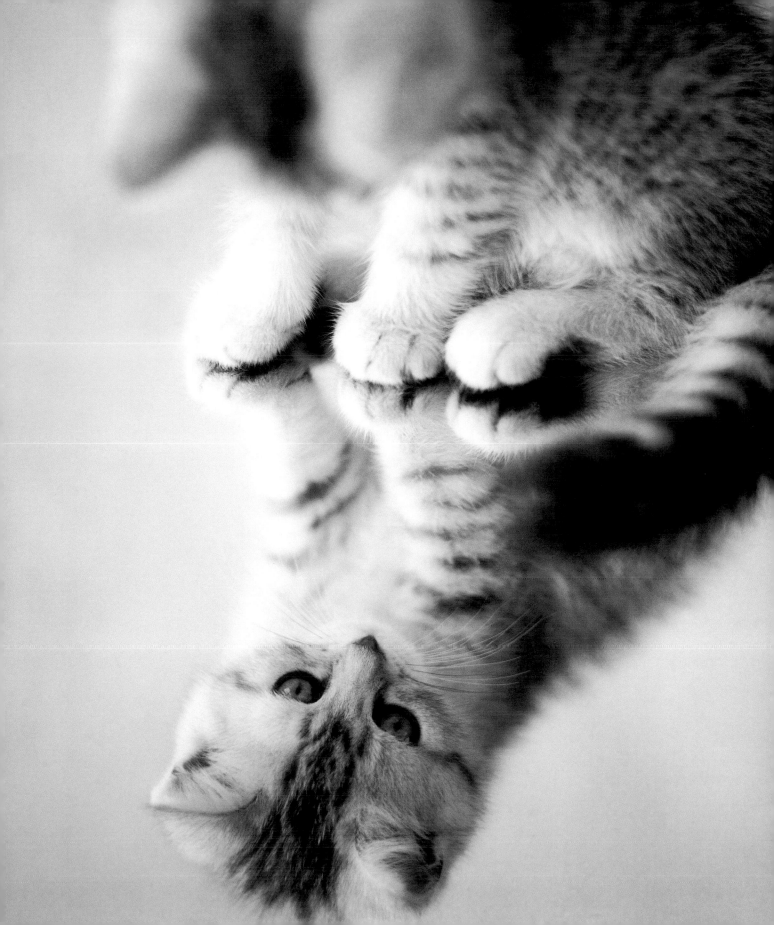

No outfit is complete without kitten hair.

RACHAEL HALE

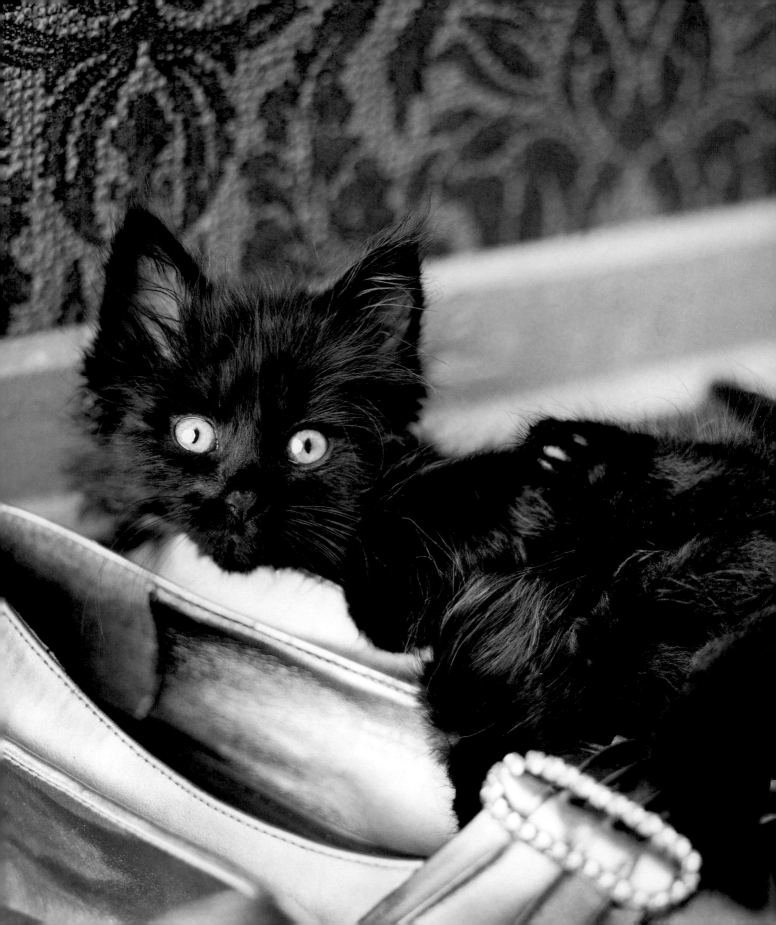

Whatever you choose to wear...

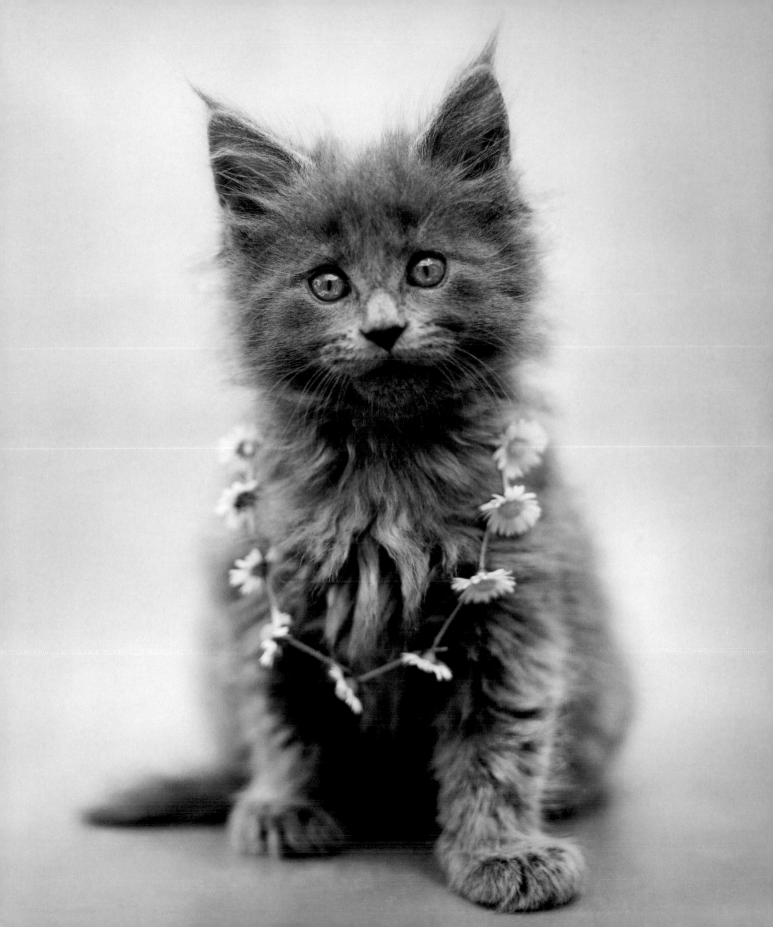

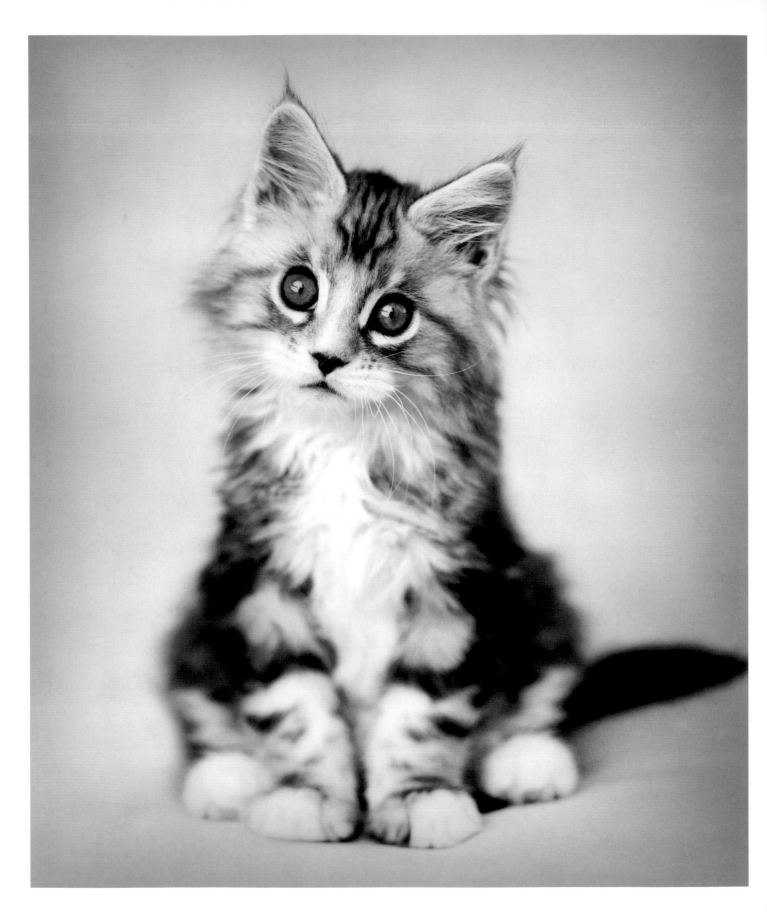

the most important thing

is your expression.

ANONYMOUS

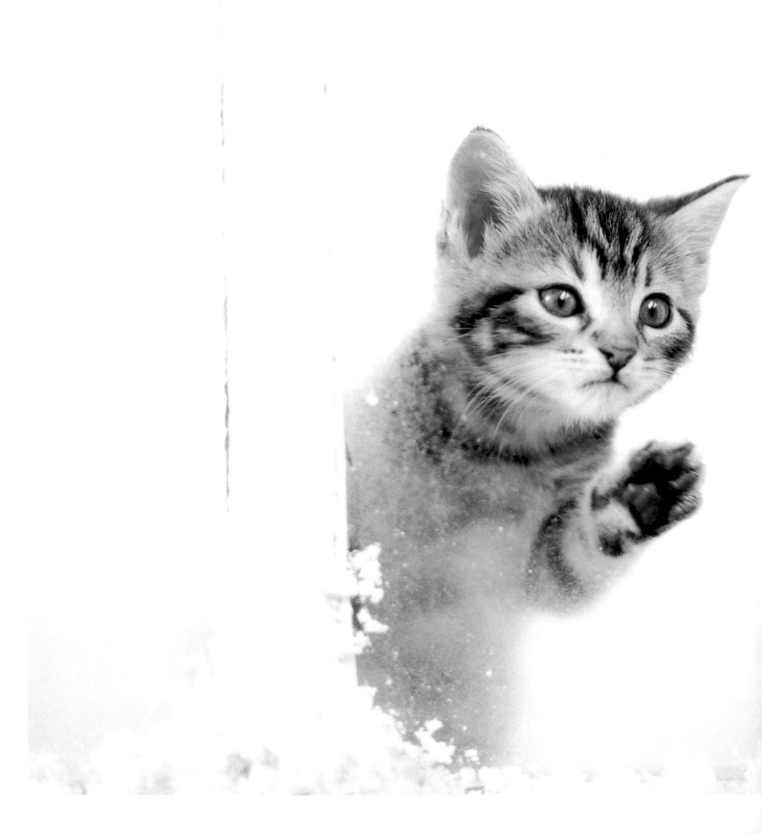

◄ TWINKLE 5 WEEKS

Life is a series of moments. To live each one is to succeed.

CORITA KENT

KALEB, KARAMELLOW & KANDY **9 WEEKS** ▶

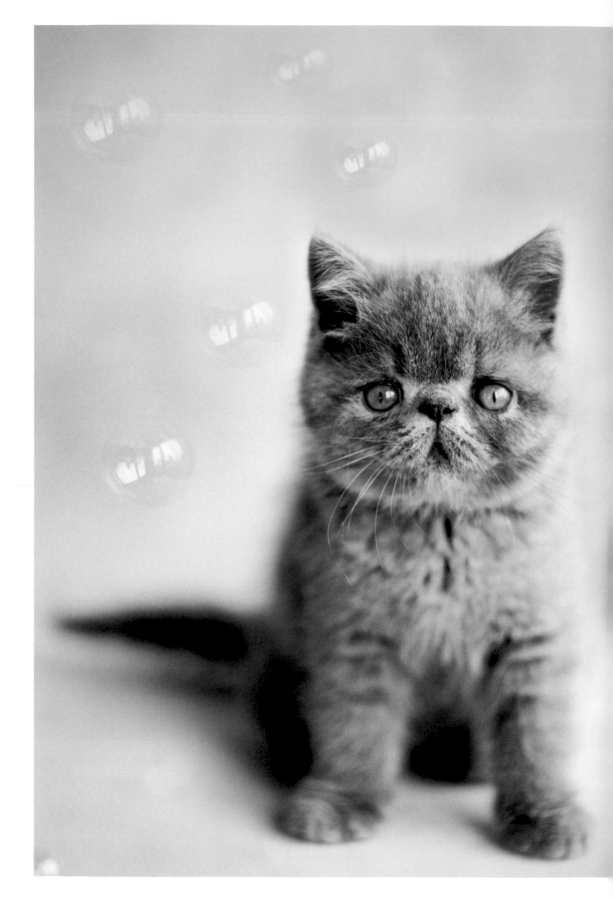

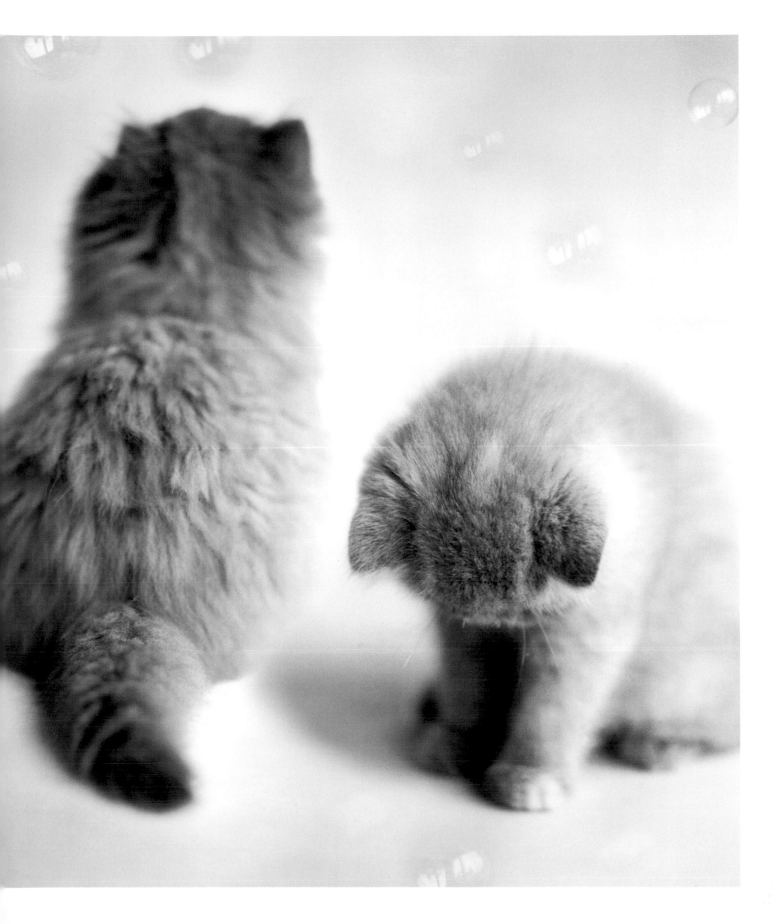

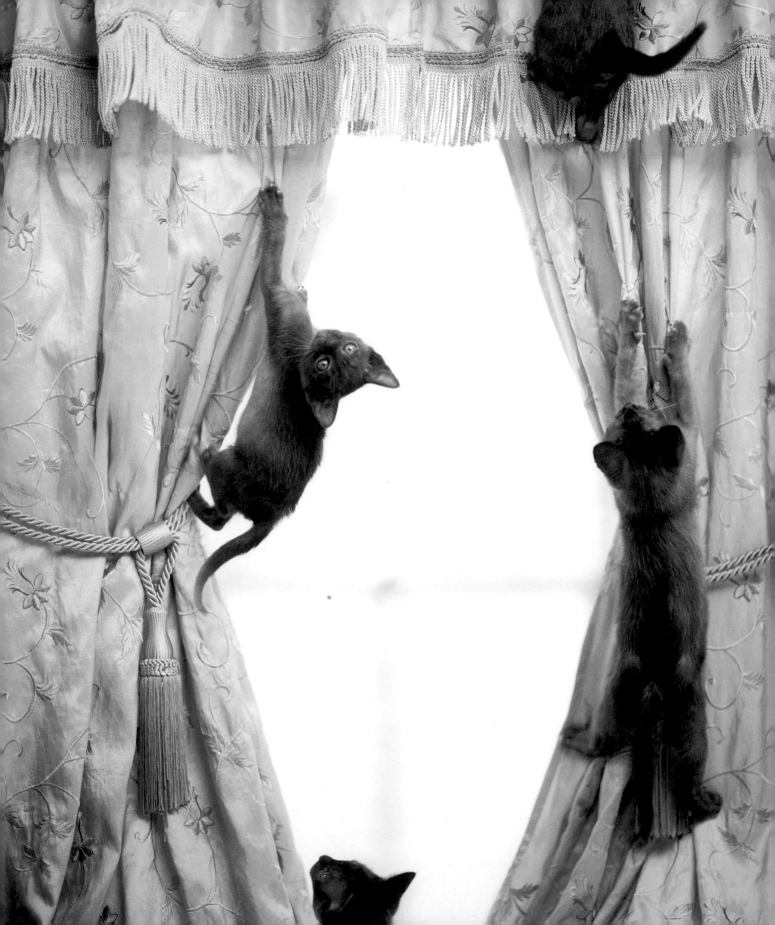

If you obey all the rules,

you miss all the fun.

KATHARINE HEPBURN

If at first you do succeed, try to hide your astonishment.

ANONYMOUS

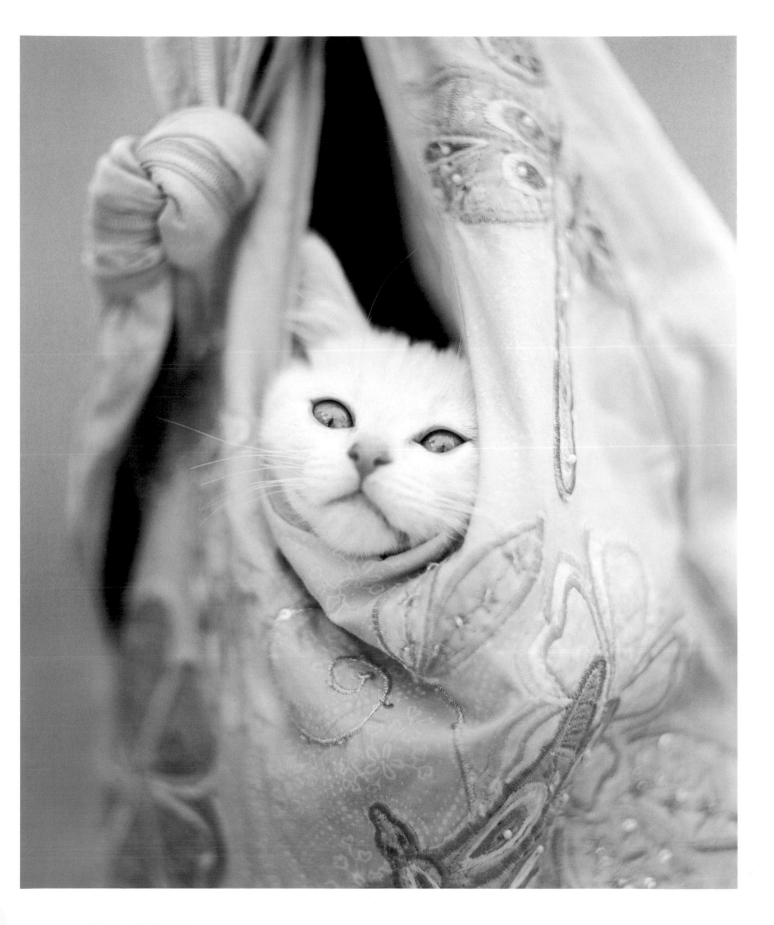

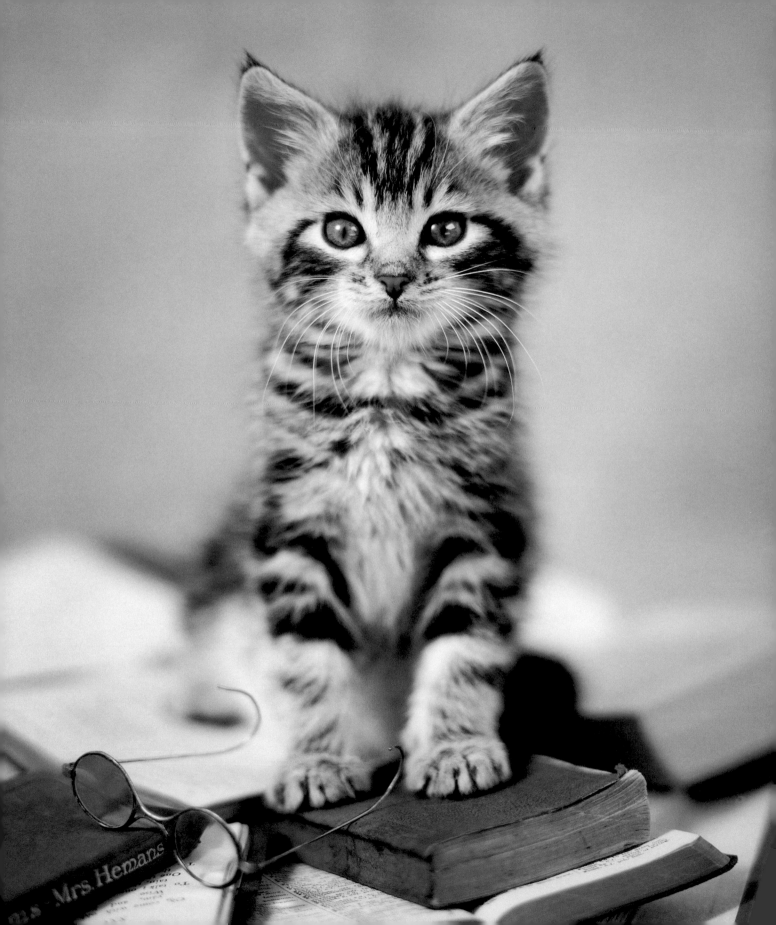

Sometimes I worry about being

a success in a mediocre world.

Success is the child of audacity.

BENJAMIN DISRAELI

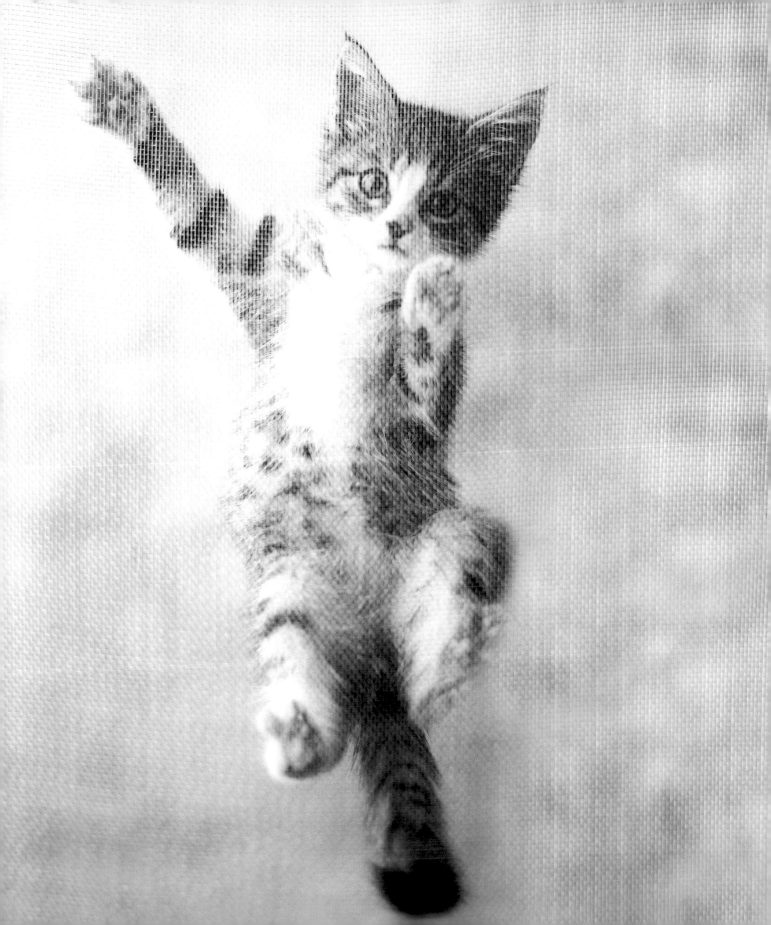

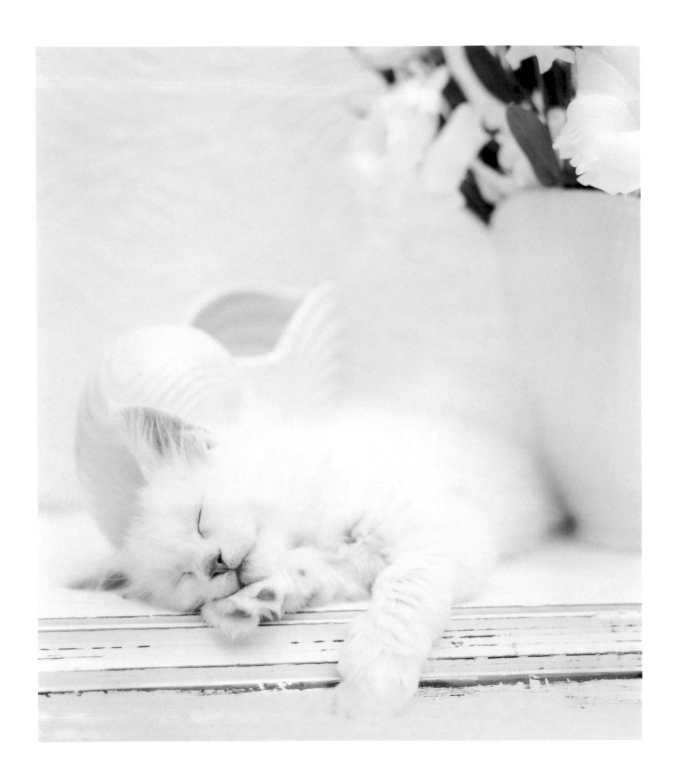

▲ PHANTOM 7 WEEKS

To accomplish great things,

we must not only act, but also dream.

ANATOLE FRANCE

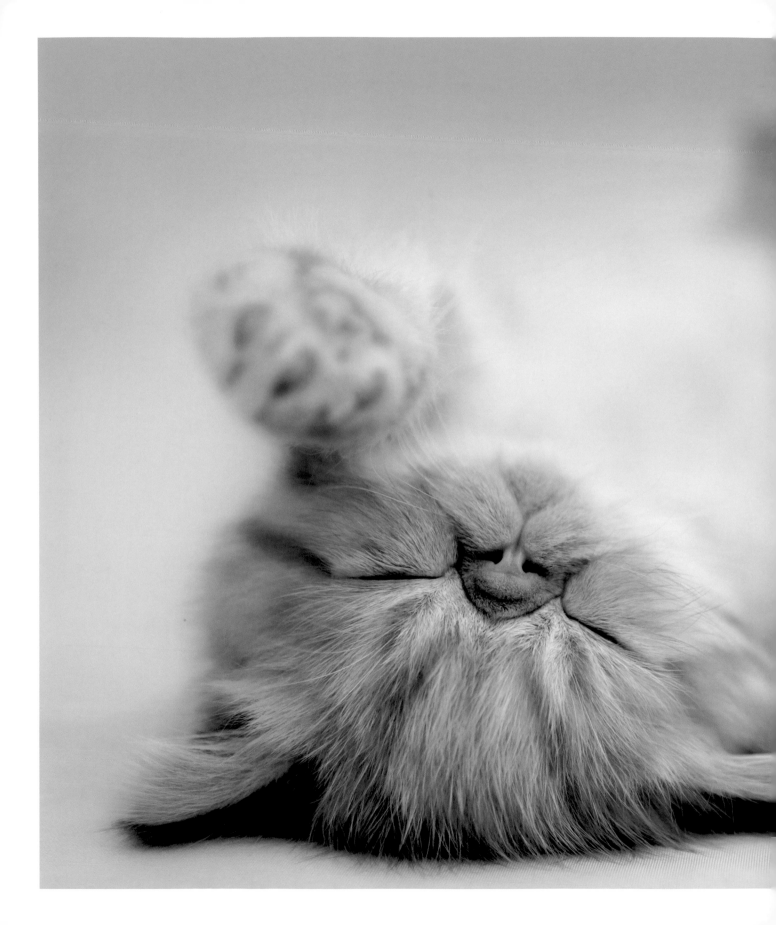

◄ TEDDY **8 WEEKS**

Never bend your head. Always hold it high.

Look the world straight in the face.

HELEN KELLER

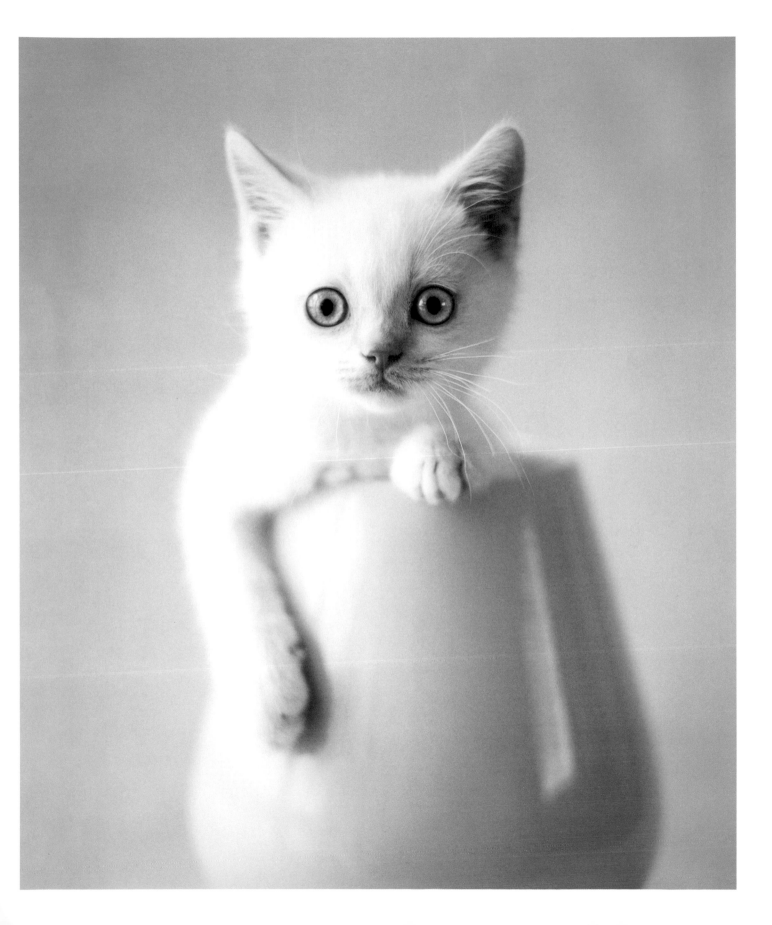

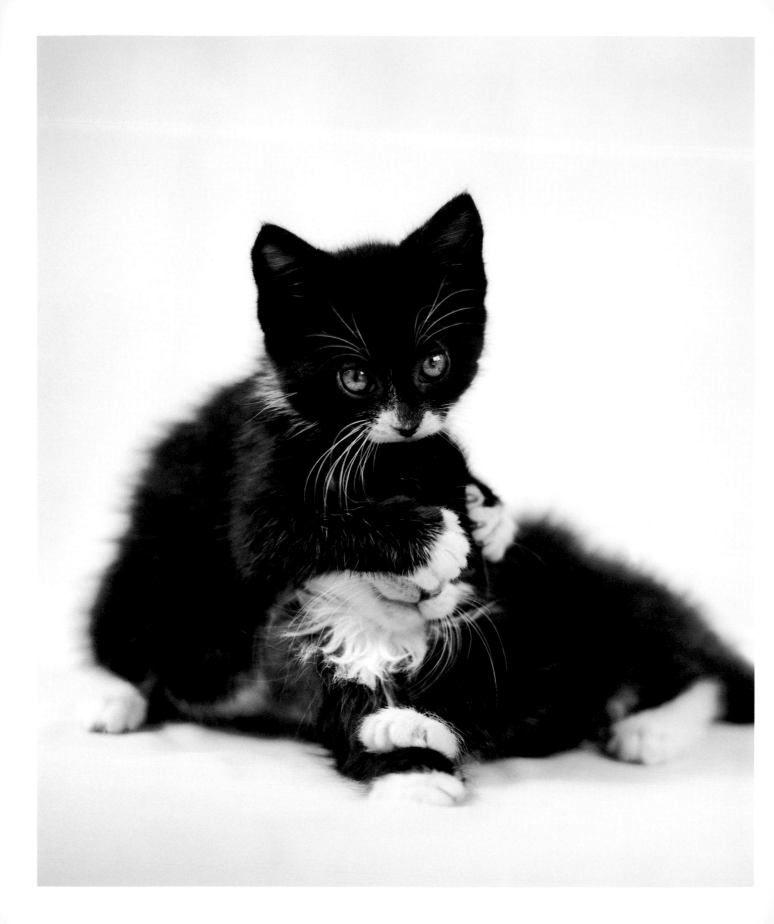

See no evil, hear no evil, speak no evil.

PROVERB

Cleanliness is next to godliness.

HEBREW PROVERB

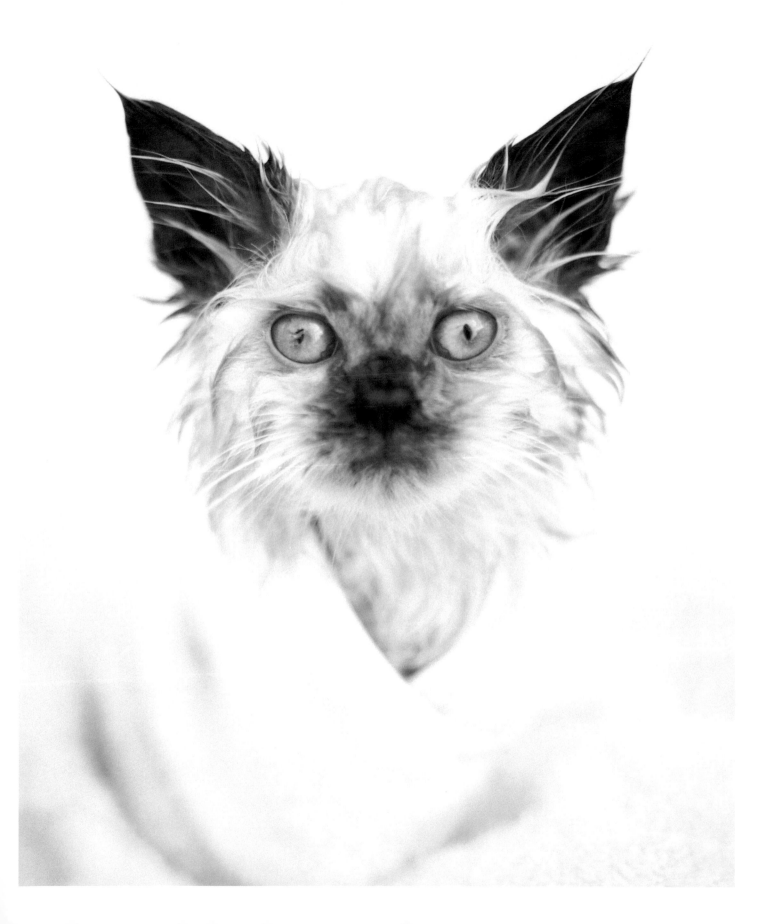

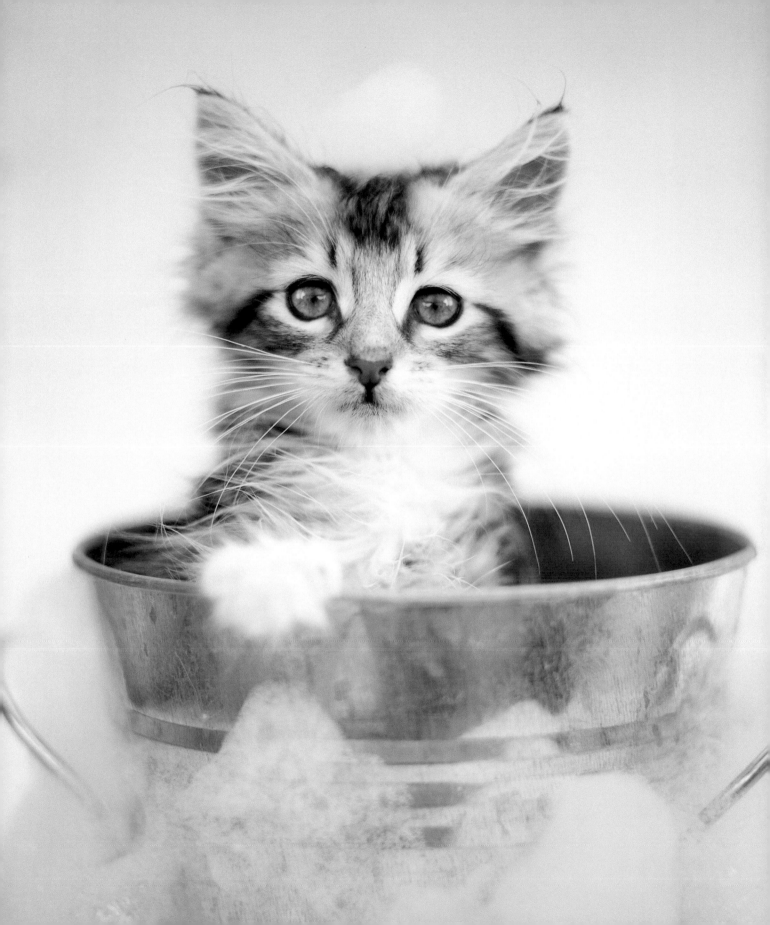

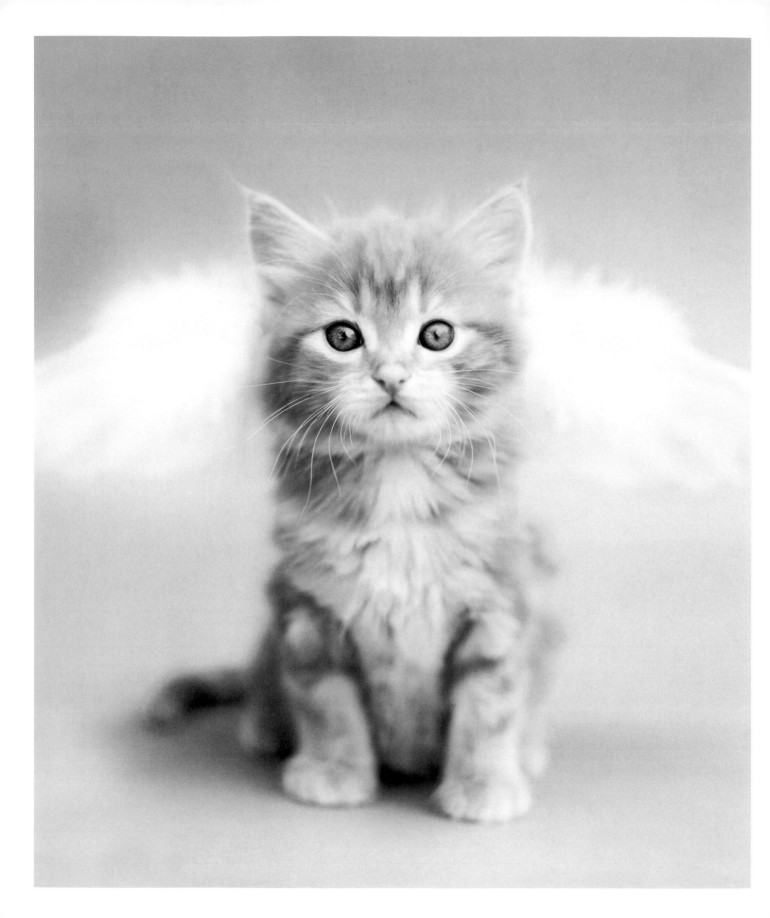

The reason angels can fly is because

they take themselves lightly.

G. K. CHESTERTON

TIMMY 6 WEEKS ▶

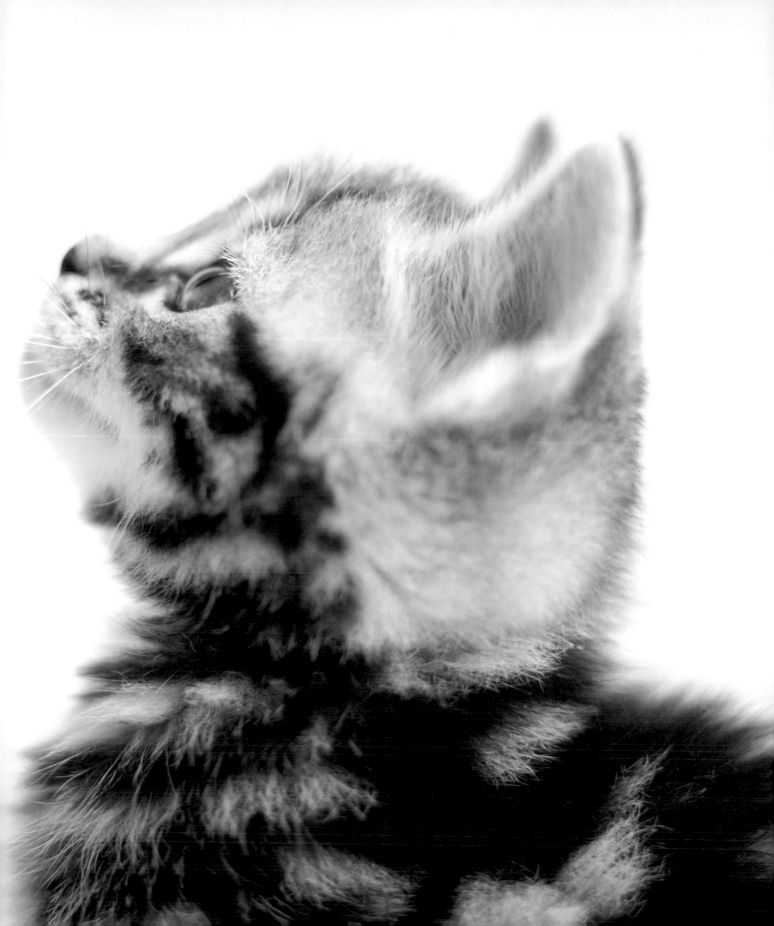

Take time to smell the roses.

RUSSIAN PROVERB

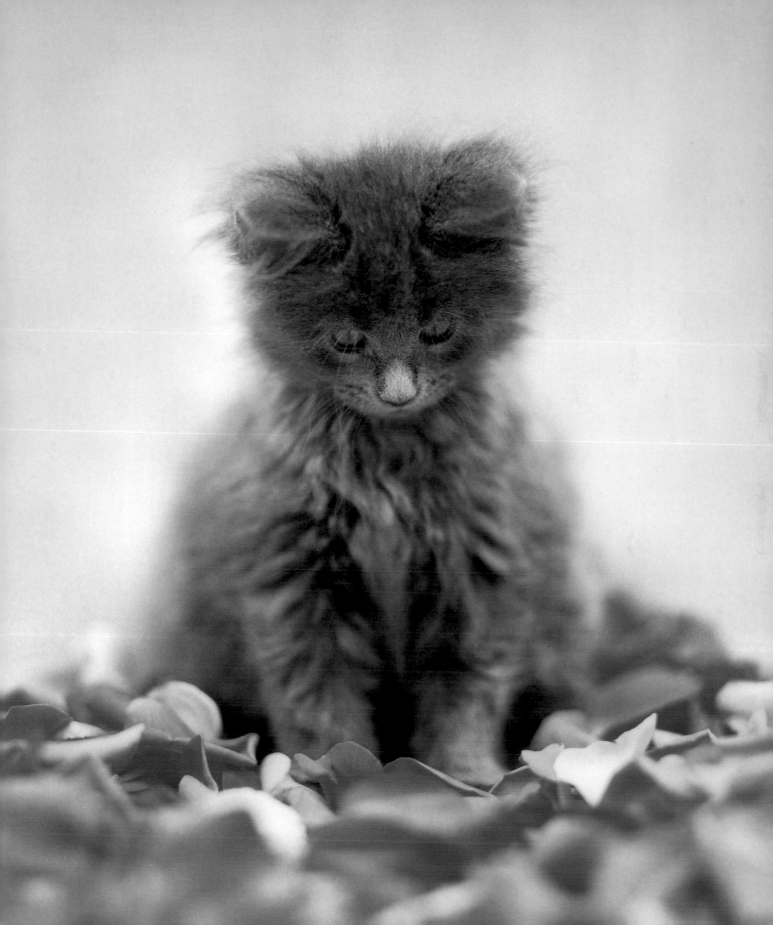

The really happy person is one

who can enjoy the scenery

when on a detour.

ANONYMOUS

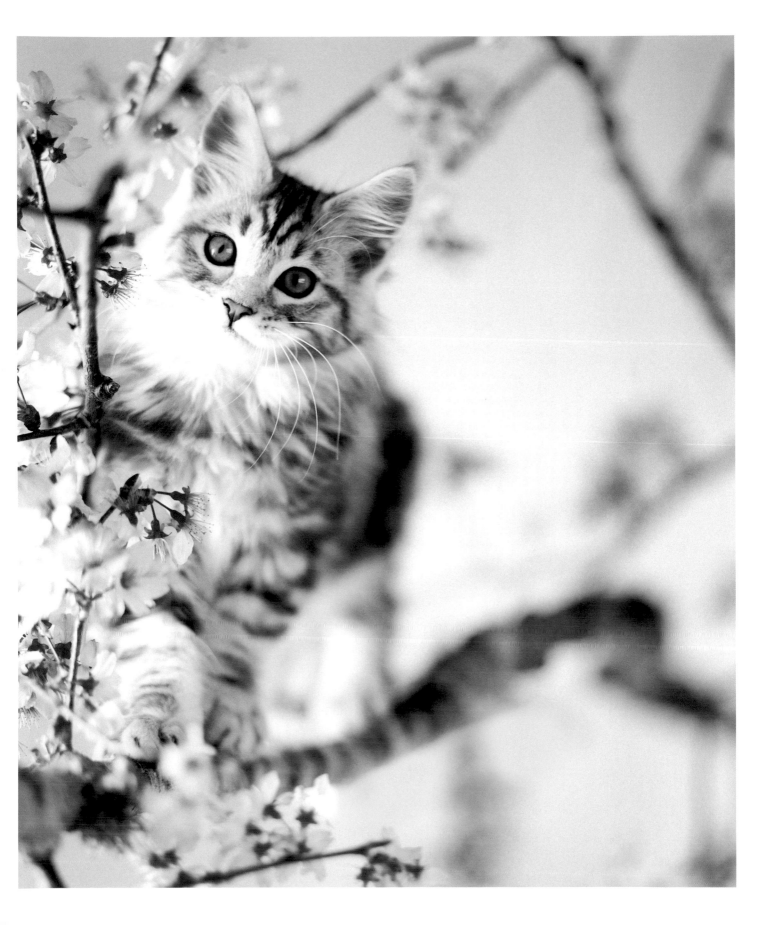

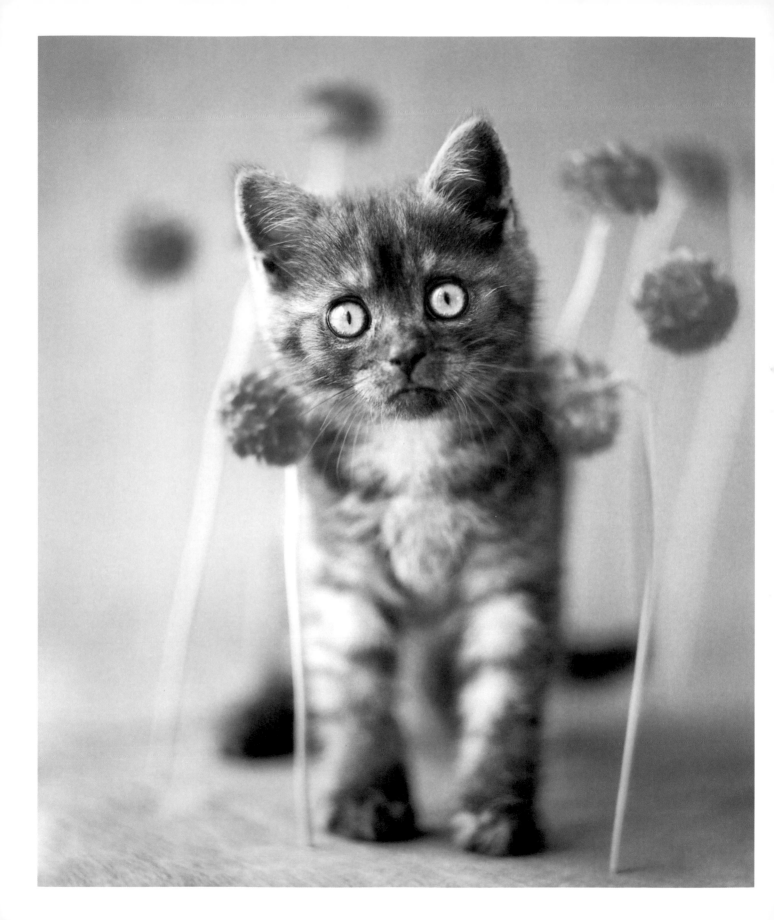

Happiness often sneaks in through a door

you didn't know you left open.

JOHN BARRYMORE

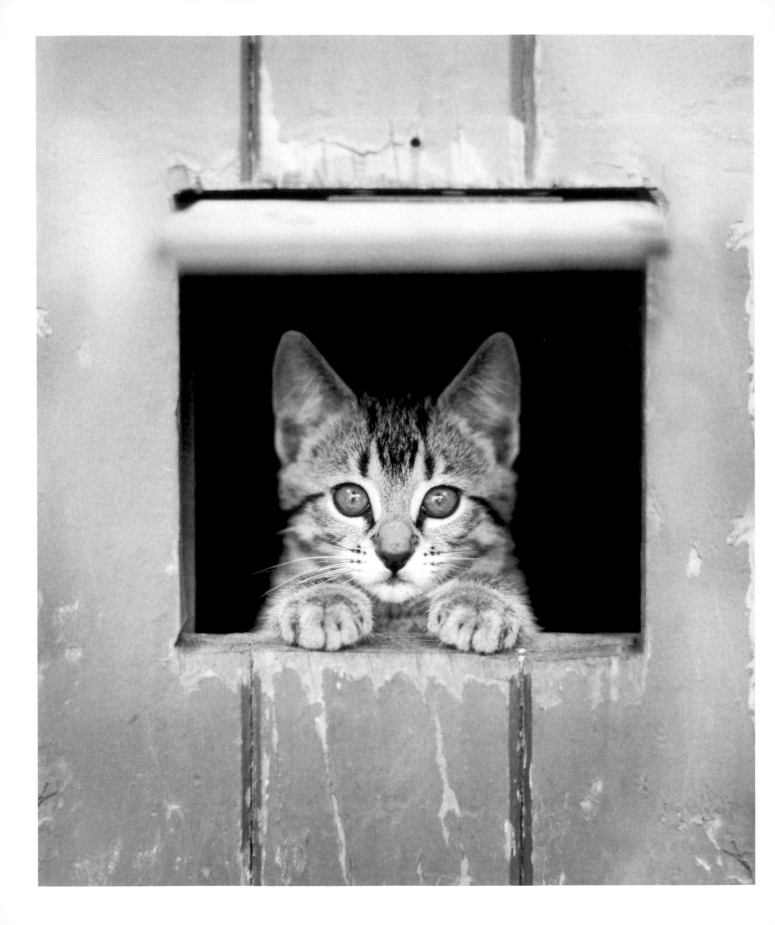

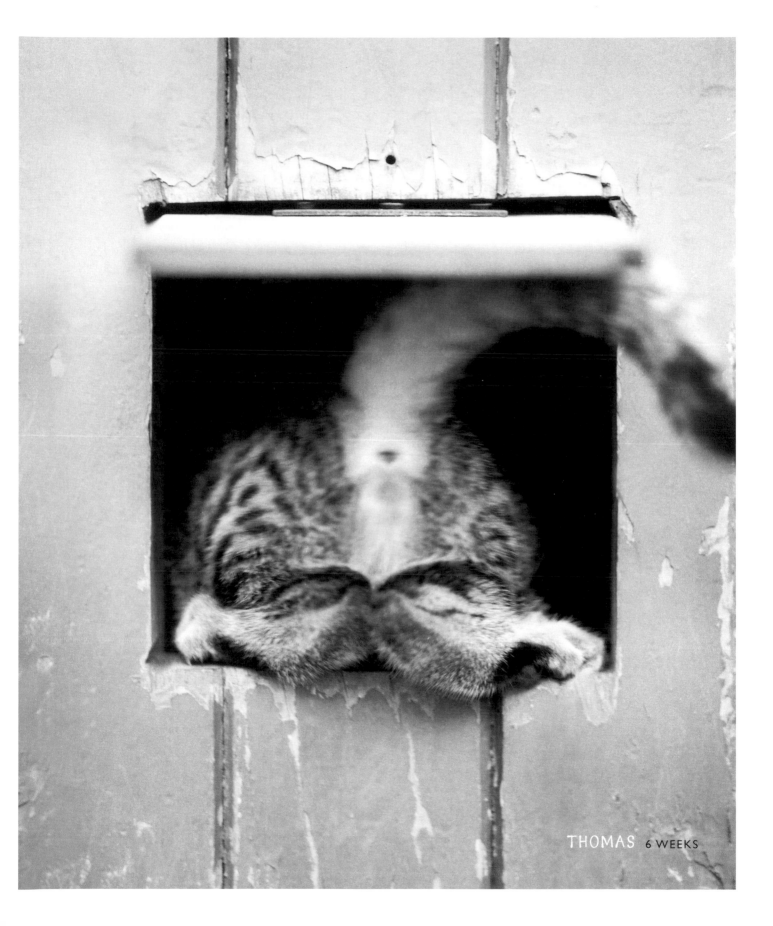

THOMAS 6 WEEKS

A little house well filled is a great fortune.

PROVERB

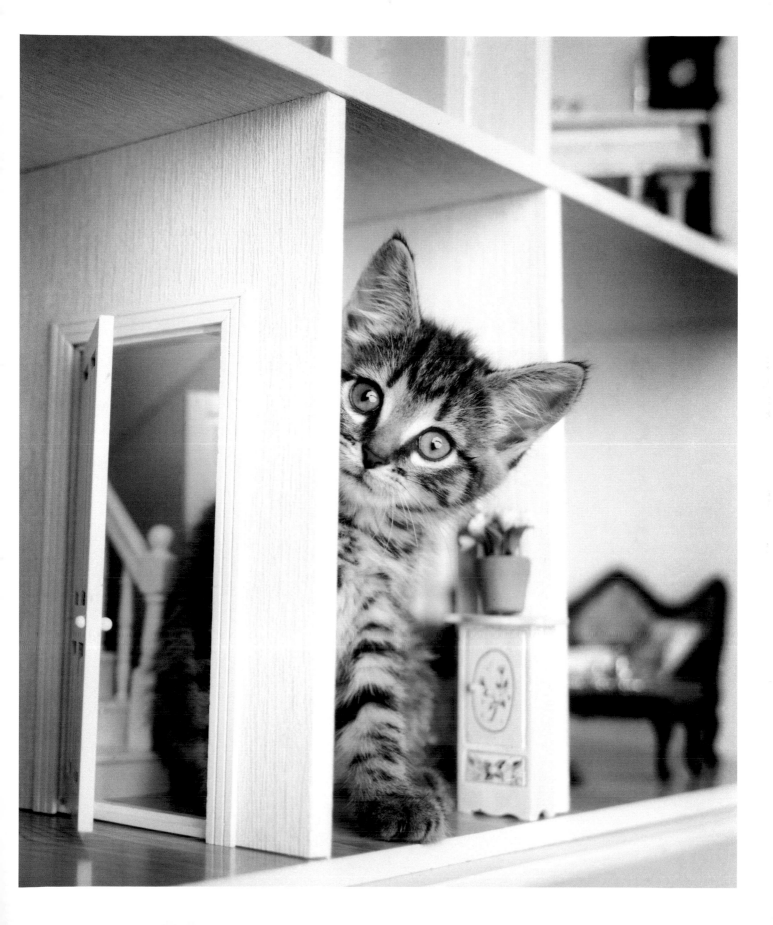

I have so much to do

that I am going to bed.

SAVOYARD PROVERB

GRACIE **9 WEEKS** ▶

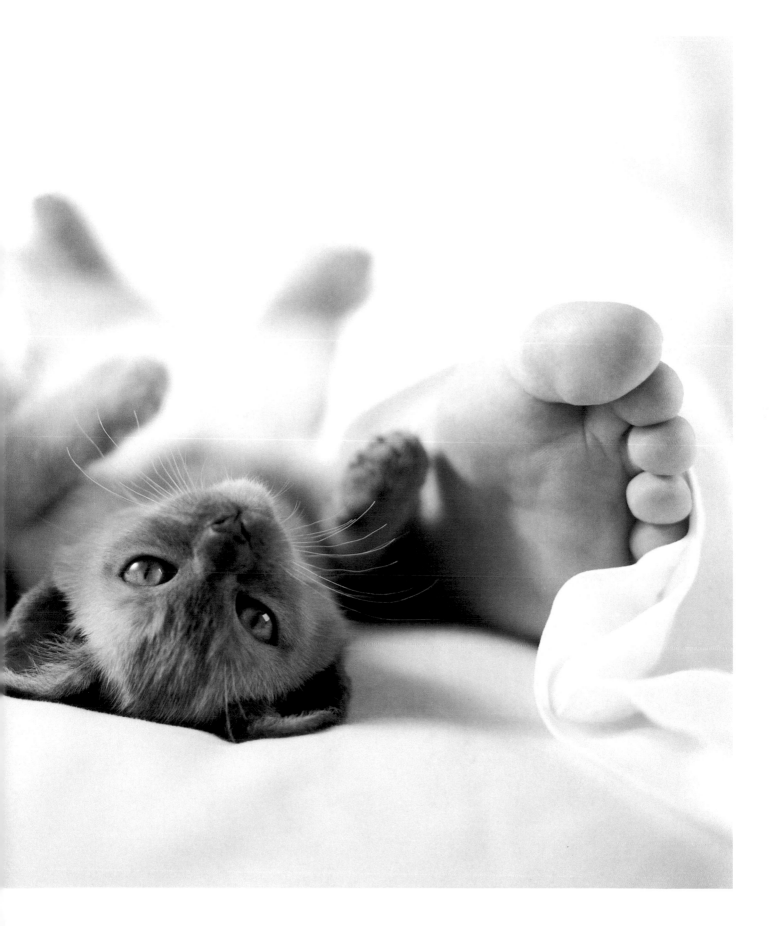

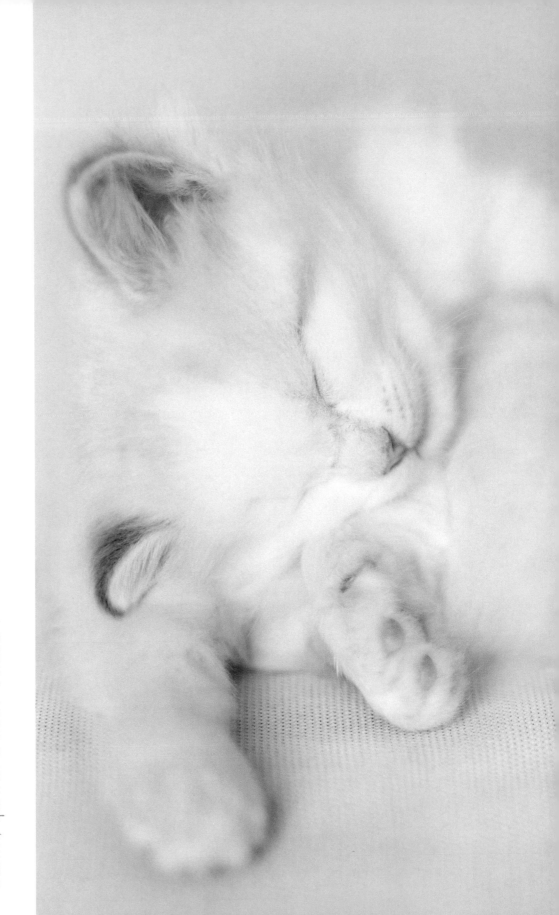

DINKY, GEMMA & RUBY 6 WEEKS ▶

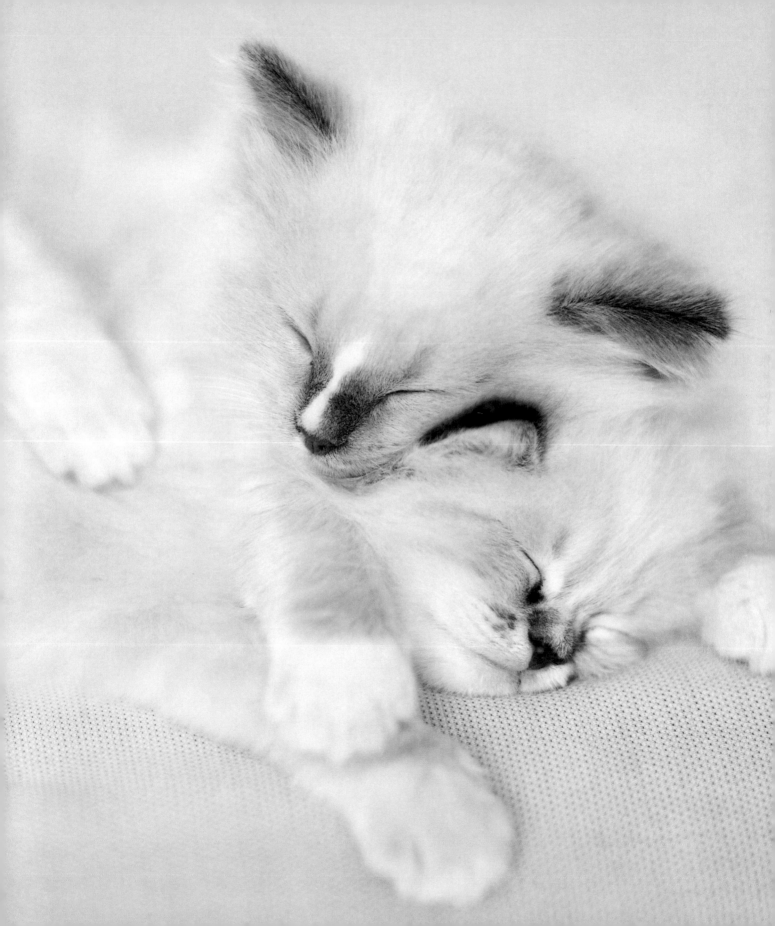

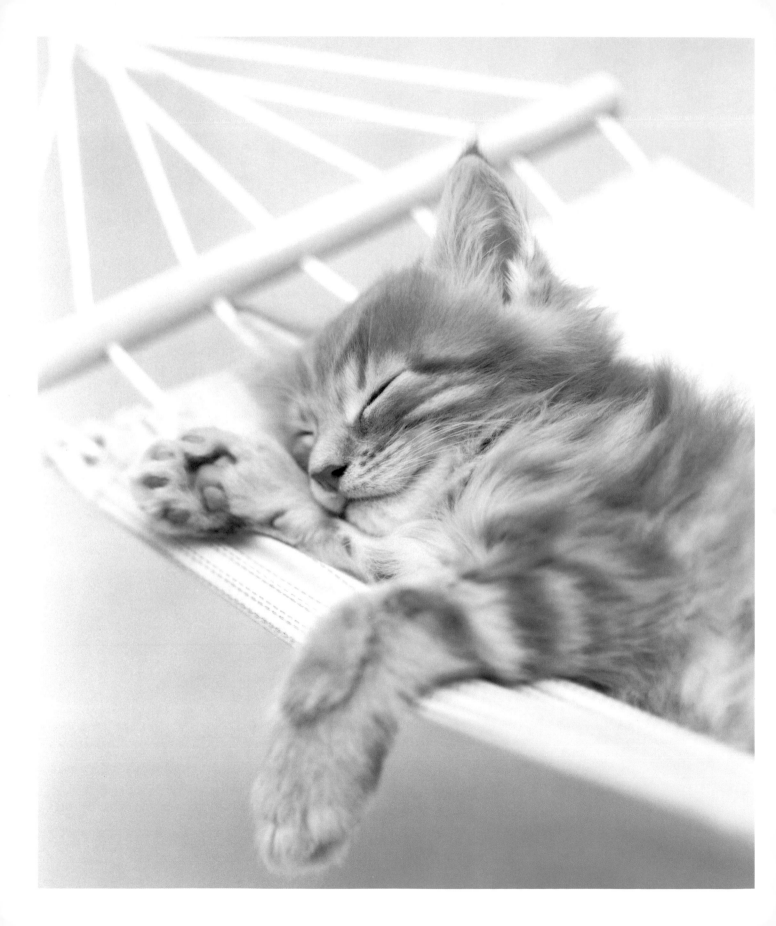

APPENDIX*

Page 2
Vega – 11 weeks old
TABBY AND BROWN PERSIAN

I am always amazed by the places in which kittens go to sleep; I certainly wasn't planning for Vega to fall asleep in this vase. She was obviously exhausted after running around with her brother Vincent.

Pages 10–11
Hunkydory – 12 weeks old
LILAC PERSIAN

The cat that got the cream! Well, in this case, the very watered down milk! But Hunkydory wasn't complaining. I was actually very lucky to capture the image of him without his tongue in the milk – it took all my efforts to pry his face out of the bottle when I had finished shooting.

Page 12
Pumpkin – 7 weeks old
CREAM HIGHLAND VARIANT

This adorable little bundle was one of the most relaxed kittens I have had the pleasure of working with. He obviously thought the hammock I had made for him was a great place to hang out – I'm sure he would have stayed there all day.

Page 15
Daisy – 7 weeks old
BLUE/CREAM POINT RAGDOLL

Daisy was the smallest of a litter of five gorgeous Ragdoll kittens, so small she often went in search of a safe place to escape the rough-and-tumble of her siblings. A pile of cozy blankets supplied by a visiting photographer proved perfect!

Page 17
Dolly – 4 months old
BIRMAN

Dolly was a real character, rolling upside down and posing in every possible "relaxed" position a kitten could manage. Who could blame her when she was given a snuggly faux fur blanket to play on.

Pages 18–19
Minnie – 3 months old
PERSIAN CROSS

Kittens love getting inside things, so it wasn't hard to encourage Minnie to venture inside a child's handbag! With the aid of a feather teaser we soon had her attention on the camera instead of playing with the handles.

Page 20
Riley – 5 weeks old
DOMESTIC TABBY

I could have taken this little guy home with me; he was so precious. After tearing around the studio with his litter-mates, it was his turn in the limelight – where he promptly fell asleep during his 15 minutes of fame.

Pages 24–25
Fantasia – 6½ weeks old
FAWN POINT TEMPLE CAT

It took a while to encourage Fantasia to make friends with the teddy bear, but once the bond was made she was smitten. She was certainly not prepared to share her new-found friend with anyone else, proceeding to cover him from head to toe in love!

Page 26
Simba – 10½ weeks old
CARAMEL DOMESTIC LONGHAIR

Simba was the craziest, most fun-loving kitten alive! I don't think I have ever seen so much energy. He would fly onto the table, charge through the tube, grab the end with his paws, then launch himself out and off the table again – I was lucky to get a shot at all.

Page 28
Lila – 5½ weeks old
CHARCOAL DOMESTIC TABBY

It was a challenge to grab Lila's attention while she was among all the sparkly jewels, but perseverance paid off when I got such an adorable look.

Pages 30–31
Jessie – 6½ weeks old
TABBY AND WHITE MAINE COON

A tummy rub, some sunshine and a soft padded bed – bliss! Jessie's expression says it all.

Page 33
Sky and Suby – 6 weeks old
CREAM MAINE COONS

Cats are commonly found on windowsills, and this one made a great place for Sky and Suby to take a nap. Have a close look at Suby's paws – he's a polydactyl and has an extra toe on each foot. This looks adorable on a kitten as their feet appear enormous.

Pages 34–35
Ziggy – 12 weeks old
BLACK-TIPPED BRITISH SHORTHAIR

Relaxed is a great way to describe Ziggy…and happy, fun, snuggly, adorable, cheeky, inquisitive…

*Please note that official terminology has been used wherever possible but names, breeds, and colors of cats vary slightly from region to region.

and willing to do anything – the perfect model.

Page 37
Humphrey – 5 weeks old
BLACK AND WHITE DOMESTIC LONGHAIR

What is it about cats and yarn? Humphrey certainly loved it, and after chasing it around the studio, he was quite happy to use it as a bed – after we had rolled it all up again, of course.

Page 39
Achilles and Apollo – 6 weeks old
RED AND WHITE EXOTICS

These two little guys were hilarious. They weren't worried at all about being up on a ledge – they had each other and were quite happy to wrestle and fool about as long as they were together.

Page 41
Bubbles and Squeak – 4 weeks old
DOMESTIC SHORTHAIRS
(TABBY AND WHITE; TABBY)

How cute are these kittens! They were so tiny. I must say they weren't quite sure why they had been placed inside glasses, but they didn't complain and were only in there for a moment.

Pages 44–45
Dinx – 10 weeks old
BOMBAY

Bombays have a lot of energy. Dinx and all his litter-mates were quite mad – in a good way – tearing around chasing each other, being typical kittens. The only way I managed to capture a shot of Dinx was for my assistant to hold him still behind the ledge and focus his attention on the camera.

Pages 47–49
Kerron – 9 weeks old
TABBY MANX

Although small, Kerron is very determined, ruling the roost in his new home. The only way to slow him down during his photo session was to put a barrier between him and the camera, which he then had to clamber through.

Page 51
Alfie – 4 months old
SEAL BI-COLORED RAGDOLL

Fun, fun, fun was all that was on Alfie's mind. He thought it was very entertaining to spin round and round in the fishbowl contorting himself into all sorts of positions.

Page 53
Eddie – 10 weeks old
GREY AND WHITE DOMESTIC LONGHAIR

Eddie proved to be an incredibly good balancer, although that's not too difficult for most cats. The challenge with creating an image like this is keeping the kitten in one spot and getting it to concentrate on the camera. Eddie was a star.

Pages 56–57
Anastasia and Victoria – 3 months old
HIMALAYAN PERSIANS
(BLUE POINT; SEAL POINT)

While these two sisters may look grumpy, they were anything but! Getting inside the paper bag was a great game. It may look like a tight squeeze, but believe me, it's all fur.

Page 58
Bear – 7 weeks old
DOMESTIC TABBY

Snuggling up to his namesakes wasn't too much of a challenge for Bear, although I'm sure he was thrilled when he was let loose again to race around the backyard with his kitten friends.

Page 61
Muggle, Nigel and Derek –
7 weeks old
DOMESTIC TABBY; GINGER DOMESTIC TABBY; TABBY AND WHITE DOMESTIC

Being let loose on an antique French chair is not something a lot of kittens have a chance to do, and these three took total advantage of the situation. They explored it from every angle, each wondering if one of the others had the best vantage point.

Page 63
Kandy and Kaleb – 9 weeks old
EXOTICS (BLUE/CREAM; BLUE)

Kandy was smaller than her brother Kaleb, but that didn't stop her squashing him against the side of the vase and keeping most of the space for herself.

Pages 64–67
Dominic and Jackson/Dominic, Sam and Jackson – 6½ weeks old
MAINE COONS (TABBY AND WHITE; BROWN TABBY)

As the saying goes, "Two's company, three's a crowd." There was plenty of room in the bucket for Dominic and Jackson, but it proved a tight squeeze when Sam jumped in.

Pages 70–71
Kokomo – 16 weeks old
BRITISH BLUE SHORTHAIR

Kokomo was such a smooge – she always had a smile on her face and was willing to do anything as long as it involved getting attention.

Page 73
Matty and Smudge –
5 weeks old, 6 months old
DOMESTIC TABBY; BROWN MOUSE

You would expect chaos when you introduced a kitten to a mouse, and there were a few playful moments when Smudge had to be whisked away to safety, but Matty and Smudge bonded very quickly, in the end even curling up together to go to sleep.

Page 74
Nigel – 7 weeks old
GINGER DOMESTIC TABBY

What a challenge to get Nigel's face out of the cream bowl! His claws were gripping the edge of the bowl as he willed us to leave it in front of him, but I couldn't let him have too much, as the last thing I wanted was for him to get an upset tummy.

Page 76
Jabulani – 9 weeks old
SEAL BURMESE

Jabulani didn't seem to mind getting chocolate on her paws, though I'm sure she would have preferred it if the fish had been ocean-dwelling creatures.

Page 79
Harry – 5 weeks old
BLACK DOMESTIC LONGHAIR

Harry was as cute as a button and nearly as small as one! I had to fill the jug with fabric so he could stand – without it his feet didn't touch the bottom.

Page 81
Bonnie and Millie – 8 weeks old
BLACK DOMESTIC SHORTHAIRS

These two sisters were right at home on the makeshift wharf – it was as if they were meant to be fishermen's cats. Playing in the net and hanging out in the tackle bag gnawing on fish seemed like something they would happily do every day.

Page 82
Frankie – 5 weeks old
BLACK DOMESTIC LONGHAIR

Another kitten that got a taste of cream! Frankie had to fight all his brothers and sisters for his position, but it was his expression that stole the show.

Page 84
Lucy – 5½ weeks old
BLACK AND WHITE DOMESTIC
LONGHAIR

At first Lucy was unsure about the music that was emanating with each footstep she took, but it wasn't long before she realized that chasing the feather teaser up and down and practicing her scales was a great game.

Page 87
Ketchup – 9 weeks old
RED TABBY PERSIAN

It was wonderful watching Ketchup discover bubbles – he was absolutely fascinated, and his gaze would follow their every move. He got rather frustrated, or should I say confused, when they kept disappearing every time he pounced.

Page 89
Buster – 6 weeks old
RED MAINE COON

Kittens and butterflies seem to go hand in hand, although in this case it was easier to control Buster's position than it was to control the butterfly, a New Zealand yellow admiral. We had to create this image in a small room so the butterfly could not fly off too far.

Page 91
Zeb – 9 weeks old
TABBY MAINE COON

Zeb was a gorgeous little kitten. He loved nothing more than a cuddle with his "Uncle Lockie," an enormous and handsome Maine Coon. I tried to photograph them together but Lockie wasn't nearly as cooperative as dear little Zeb.

Page 92
Jitterbug – 5 weeks old
LILAC POINT PERSIAN

Normally a kitten would wriggle and squirm when held in a position like this, but Jitterbug was willing to oblige for a minute or so, hanging perfectly still so I could capture an image.

Page 95
Henry – 8 weeks old
SILVER TABBY BRITISH SHORTHAIR

I wasn't sure if Henry would be interested in looking at himself in the mirror, but he proved to be quite intrigued by the handsome kitten looking back at him.

Pages 98–99
Lizzie – 6 weeks old
BLACK DOMESTIC LONGHAIR

Kittens are so adorable when they find snug places to curl up in. We made the perfect place for Lizzie among some shoes and she happily squeezed into a size 8 – a tight fit but not uncomfortable.

Page 101
Lara – 7 weeks old
BLUE MAINE COON

Lara has to be one of my favorite kittens. Not only is she the first-ever Blue Maine Coon bred in New Zealand, but she has one of the sweetest faces and personalities. What's more, she has what every photographer loves – she's fantastic to work with!

Page 102
Katie – 8 weeks old
SILVER MAINE COON

Her expression says it all – pick me, I'm the cutest! And while Katie was cute, so were all seven of her brothers and sisters. I definitely have a soft spot for Maine Coons, the gentle giants of the cat world.

Pages 104–105
Twinkle – 5 weeks old
DOMESTIC TABBY

The SPCA tabbies just make my heart melt, especially when they are perfect in every way – playful, affectionate, gentle – and give me a pose that makes the perfect shot!

Pages 108–109
Kaleb, Karamellow and Kandy – 9 weeks old
BLUE EXOTIC; CHOCOLATE PERSIAN; BLUE/CREAM EXOTIC

Like Ketchup, their litter-mate, Kaleb, Karamellow and Kandy were completely fascinated with the bubbles, chasing them all over the place and popping them with gusto.

Page 110
Dudley, Sage, Thombi and Jabulani – 9 weeks old
SEAL BURMESE

Climbing the curtains is not something I usually encourage kittens to do, but they love it so much that it's hard not to let them sometimes. These curtains were made especially for the shoot – hopefully the kittens didn't think it was normal behavior to tear up the curtains when they went to their new homes.

Page 113
Murphy – 8 weeks old
CAMEO DOMESTIC SHORTHAIR

Kittens love bags, and Murphy was no exception. He wouldn't pay any attention to us until he had explored every corner of this one, and then all I got was a glance out through the opening.

Page 114
Billy – 5 weeks old
DOMESTIC TABBY

When I first saw these books I couldn't believe how tiny they were – they fit into the palm of my hand. This just shows how tiny Billy is – even the minute glasses were too big for him.

Page 117
Derek – 7 weeks old
TABBY AND WHITE DOMESTIC

Climbing the screen was a piece of cake for Derek. He was up and down in seconds – the challenge was trying to keep him still and stopping all his kitten friends from joining him halfway up the screen.

Page 118
Phantom – 7 weeks old
WHITE MAINE COON

Sleep is a necessity for kittens, and when rest is needed, they tend to take a nap anywhere, any time. In this case, Phantom had been playing with his siblings on the mantelpiece, and in the warmth of the sun, he found the perfect spot for a cat nap.

Pages 120–121
Teddy – 8 weeks old
RED TABBY EXOTIC

It's the sign of a very relaxed and happy cat when they are comfortable enough to sleep on their back, totally exposed to the world. That's exactly how Teddy felt after a morning of play with his litter-mates and his new-found friend the photographer.

Page 123
King – 9 weeks old
RED POINT BRITISH SHORTHAIR

King's expression says it all – he was astonished at the sound of the squeaky toy my assistant was using to draw his attention toward the camera. Despite his expression, he was having a great time bobbing up and down in the vase.

Page 124
Lewis and Humphrey – 5 weeks old
BLACK AND WHITE DOMESTICS

A bit of rough-and-tumble with your brother never goes amiss – even though Lewis took advantage of poor Humphrey, pouncing on him while he was asleep and taking him by total surprise.

Page 127
Dusty – 10 weeks old
BLUE POINT HIGHLAND VARIANT

Living up to his name, Dusty needed a bath! Though it wasn't his most enjoyable experience, he coped extremely well, and was soon back with his friends, running around, causing chaos and getting dirty.

Page 129
Moto – 7 weeks old
DOMESTIC TABBY LONGHAIR

Although Moto didn't really like the idea of having a bath, she did think it was great fun to play with the foam and bubbles. So we let her off and didn't add any water, much to her relief.

Page 130
Jerico – 7 weeks old
GINGER DOMESTIC TABBY

It was the cutest sight watching Jerico wander around wearing his little angel wings. They were slightly too big for him and made him a bit unstable, but it didn't take him long to get his balance and then to focus his attention on the camera.

Pages 132–133
Timmy – 6 weeks old
DOMESTIC TABBY

I have always loved the delicate features of kittens' faces, and Timmy was exquisite. Even the shape of his head was perfect, and his button nose was irresistible.

Page 135
Lara – 7 weeks old
BLUE MAINE COON

Lara was hilarious playing among the rose petals. When we dropped them from above she would pounce with great enthusiasm and roll over on her back to catch them. In this photo, one had just landed at her feet; her fur is all puffed up as she gets ready to pounce.

Page 137
Sofurry Loren – 11 weeks old
SILVER MAINE COON

Sofurry Loren is a picture of beauty – delicate in features and light on her feet. I had eleven Maine Coon kittens in the studio this day, but Sofurry Loren was the only one willing to climb the blossom tree – thank goodness she was so picture perfect.

Page 138
Stanley – 8 weeks old
BLACK SMOKE BRITISH
SHORTHAIR

I have always loved the look of flowering chives – they look like pompoms on sticks. Stanley seemed to like them too, as he wandered through having a sniff here and there and batting them from side to side with his paws.

Pages 142–143
Thomas – 6 weeks old
DOMESTIC TABBY

This was Thomas's favorite game – racing in and out of his cat door – and one I couldn't resist photographing. It was a challenge getting the focus, though, as the more often Thomas jumped through the faster he seemed to get.

Page 145
Leroy – 5 weeks old
DOMESTIC TABBY

Kittens always seem fascinated with dolls' houses, and it is amusing watching them roam around and explore. I had three kittens inside this house – one had curled up and gone to sleep on the bed, another was perched on the miniature piano, and Leroy was content to hang out in the hallway.

Pages 146–147
Gracie – 9 weeks old
CHOCOLATE BURMESE

A picture of total relaxation! I remember when I was a child and we had kittens, they always used to jump on the bed and attack our feet at bedtime. Elizabeth had her feet wrestled with before Gracie decided it was far too comfortable a space not to take advantage of.

Pages 148–149
Dinky, Gemma and Ruby –
6 weeks old
RAGDOLLS (BLUE LYNX
BI-COLOR; BLUE LYNX MITTED
WITH BLAZE; BLUE LYNX MITTED)

After they had spent all morning running around playing, it didn't surprise me when these little kitties finally crashed. They were so exhausted it wasn't too hard to move them around into the

perfect positions, although neither was it long before troublemaker Dinky woke them up again.

Page 150
Brian – 6 weeks old
RED MAINE COON

You would never have guessed that minutes before this image was taken Brian was tearing around the room not showing any signs of wanting to go to sleep. It always amazes me that when a kitten really needs to sleep it tends to happen in an instant. They fight it as hard as they can, then they just have to give in.

ACKNOWLEDGEMENTS

Working with kittens can be extremely challenging at times, but it is always great fun and incredibly rewarding. Patience is the most important aspect of creating photographic images of animals, and something that is absolutely essential when working with kittens. Although I never know if an image is going to take one or seven hours to create, the great thing about working with kittens is that they are so entertaining. I never mind how long it takes, as they always keep a smile on my face.

Creating a collection of images for a book like *Smitten* would not be possible without the help of a great many people. I am very thankful that my assistant Charlotte Anderson is also fond of kittens – there were many subjects that we both would have loved to take home. Thank you, Charlotte, for your endless patience and incredibly delicate touch in handling the kittens, especially when moving the sleeping ones into the perfect position. I would also like to thank my special friend Rae Jarvis, who is always keen to lend an animal-loving hand, even when I phone her when in the middle of a shoot in desperate need of another set of hands – thank you, you know how much I value your support.

The BIGGEST thanks go to Geoff Blackwell and Ruth-Anna Hobday of PQ Blackwell. You continue to make my dreams come true – the support and encouragement you continually give me is invaluable, your belief in my imagery is what all artists dream of. Caroline Bowron, Jenny Moore and the rest of the amazing team at PQ, a huge thank you for all the efforts you have put into making *Smitten* such a success. Though I have to say, Jenny, your kitten Kerron was one of the more challenging subjects, so I'm not sure I should be thanking you for that.

Kate Hennebry, thank you so much for your fantastic styling skills; I so enjoyed working with you and look forward to us spending more time in the future creating images together.

Many thanks to the team at Rachael Hale Photography Ltd., especially Robine Harris for your retouching skills – you always manage to understand exactly how I want the final image to look, adding the finishing touch to make each one perfect.

An ENORMOUS thank you to all the kittens and their owners and the breeders who so generously invited me into their homes to work with their precious babies. I hope you are as proud of the end result as I am – it would not have been possible without your beautiful kitten models.

I would like to give a special thanks to Bob Kerridge and the incredible team at the Auckland SPCA for their continuing support and the trust they placed in me by allowing me to photograph so many of the adorable kittens that pass through their doors. "Foster mums" – thank you for not only allowing me to photograph your charges but also for so generously looking after the kittens that are too young to go up for adoption. I know the kittens appreciate the love you give them. If you have adopted a kitten from the SPCA, thank you for opening your home to a precious new family member – maybe one of the kittens in this book is now sleeping peacefully on your lap!

I am very grateful to the many businesses that aid me in the creation of my images, especially Image Centre (scanning), PCL (color printing and processing), Labtec (color and black and white printing) and Apix Photographic Supplies.

A heartfelt thank you to my good friends Brent and Gina-Marie Franich – your advice, guidance and encouragement have been a huge support, and I really can't thank you enough.

Finally, to my friends and family, who are always there when most needed – special thanks to my parents Bob and Barbara, my twin sister Rebecca and my closest friends Rae, Jo and Kirstin.

Last but not least is my own little fur family, Eddie, Gianni and Versace. Sorry you didn't make it into this book – you're a bit too old!

Bulfinch Press
Hachette Book Group USA
1271 Avenue of the Americas, New York, NY 10020
Visit our Web site at www.bulfinchpress.com

First North American Edition: October 2006
Published by arrangement with PQ Blackwell Limited

ISBN-10: 0-8212-5848-6
ISBN-13: 978-0-8212-5848-4

Library of Congress Control Number 2006926261

Printed by Everbest Printing, China